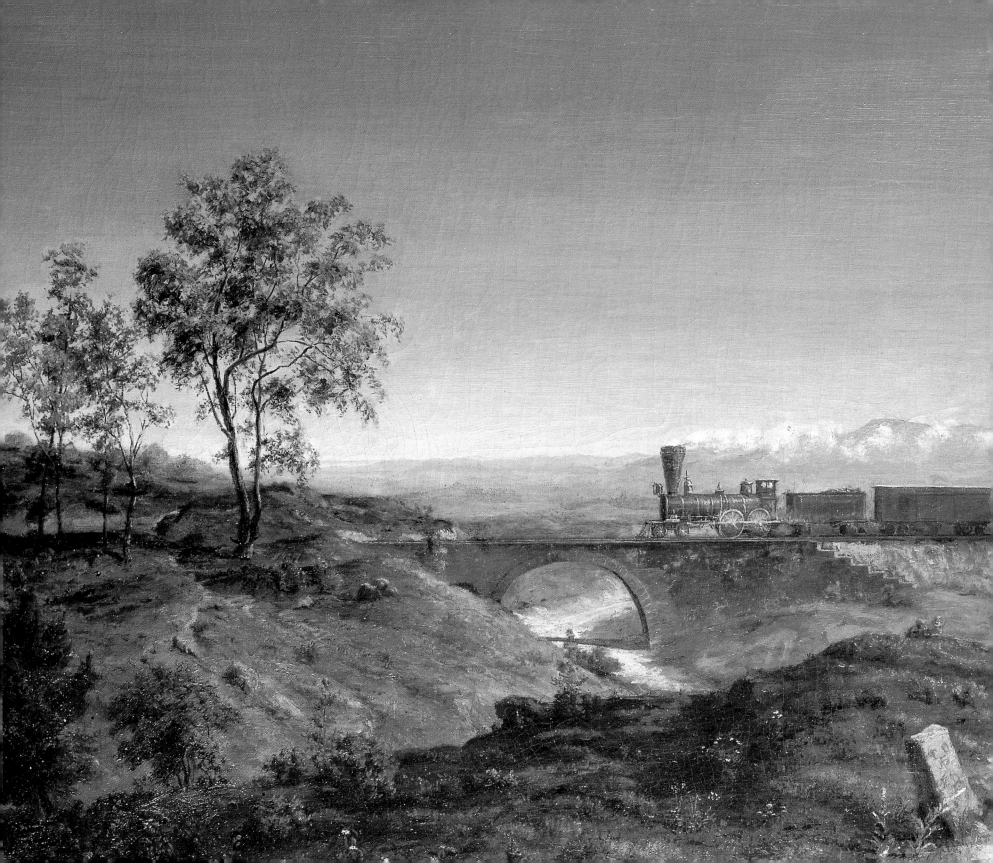

THE AMERICAN WEST
OUT OF MYTH, INTO REALITY

PETER H. HASSRICK, GUEST CURATOR

TRUST FOR MUSEUM EXHIBITIONS
IN ASSOCIATION WITH THE MISSISSIPPI MUSEUM OF ART

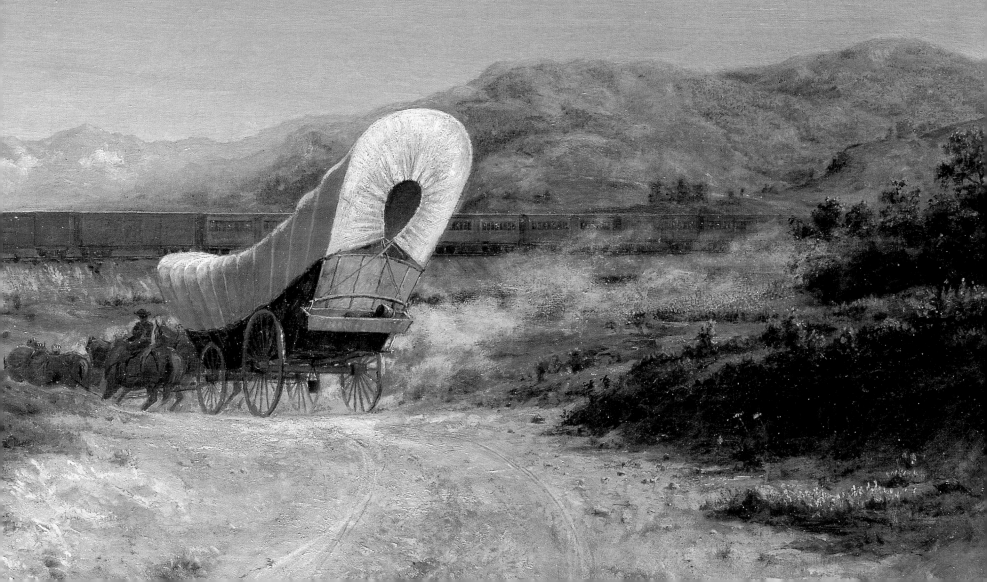

Published in 2000 by the
Trust for Museum Exhibitions
1424 16th Street, N.W.
Washington, D.C. 20036

ISBN: 1-882507-08-8

Prepared for publication by
Archetype Press, Inc., Washington, D.C.
Diane Maddex, Project Director
Gretchen Smith Mui, Editor
Carol Kim, Editorial Assistant
Robert L. Wiser, Designer

PHOTOGRAPH CREDITS

Damian Andrus: 160 (left)
Will Brown: 40, 49, 63, 76, 114, 141, 147
Ken Burris: 129 (left)
David Campli: 84 (left)
Richard Carafelli: 117
Richard Faller: 57
M. Lee Fatherree: 4–5, 160
Gretchen Haien/Studio 4, Inc.: 20, 144
Rick Hall, Jack S. Blanton Museum of Art: 152
James Milmoe: 94
Larry Sanders: 71
Craig Smith: 14
Szabo/Stacy Kollar: 67 (left), 176
Joseph Szaszfai, Yale University Art Gallery: 73
Lucille Warters: 149
Patrick J. Young: 125

Front cover: Charles Deas, *A Solitary Indian, Seated on the Edge of a Bold Precipice* (detail), 1847
Back cover: John Mix Stanley, *Chain of Spires along the Gila River* (detail), 1855
Page 1: Alexander Phimister Proctor, *The Indian Warrior* (detail), 1898
Pages 2–3: Thomas P. Otter, *On the Road* (detail), 1860
Pages 4–5: John Gast, *American Progress* (detail), 1873
Pages 6–7: Maynard Dixon, *The Earth Knower* (detail), 1933–35
Pages 12–13: Thomas Moran, *Hopi Village, Arizona* (detail), 1916
Pages 58–59: Carl Wimar, *Indians Approaching Fort Union* (detail), 1859.
Pages 170–71: Thomas Hill, *Yosemite Valley* (from below Sentinel Dome, as Seen from Artist's Point) (detail), 1876
Page 176: Frederic Remington, *The Broncho Buster* (detail), 1895

All images shown in detail also appear in their entirety elsewhere in the catalogue.

Printed in Hong Kong

10 9 8 7 6 5 4 3 2 1

First printing

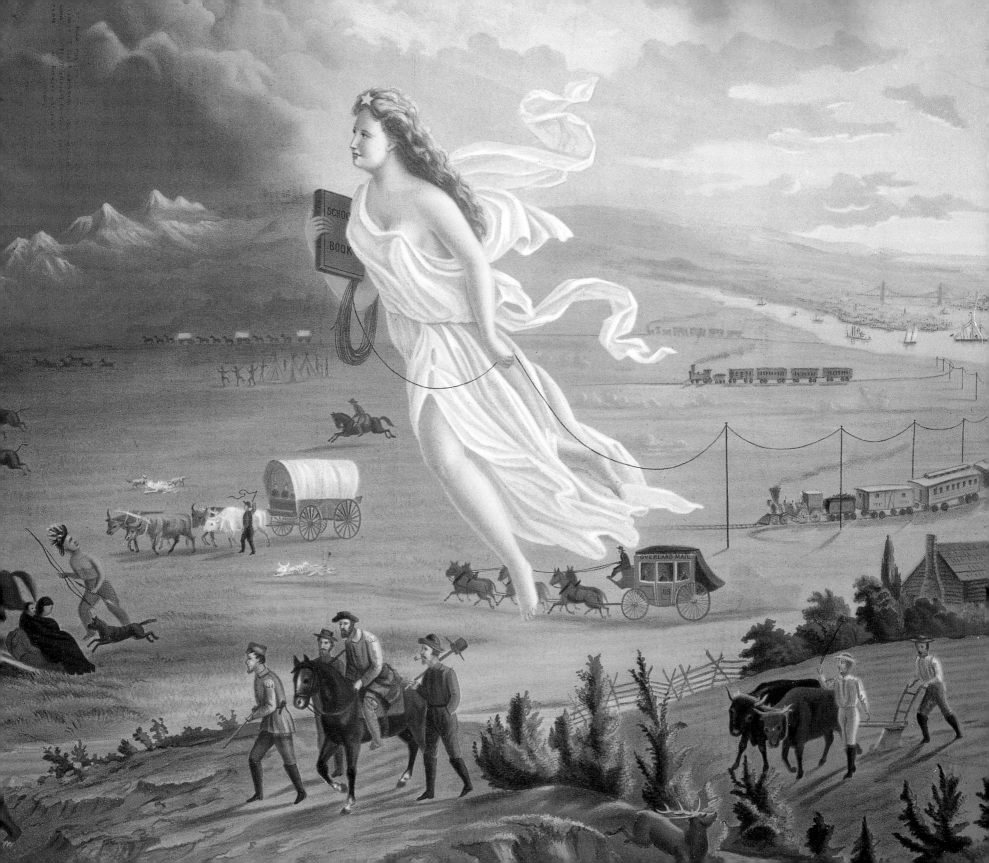

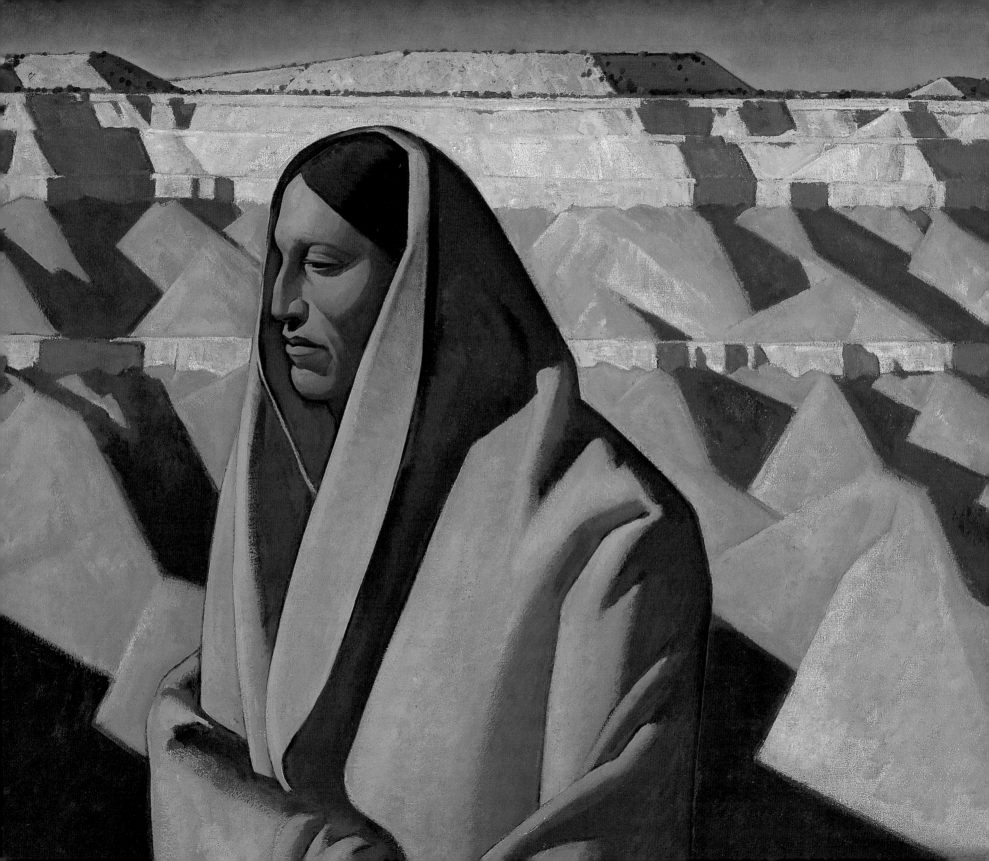

CONTENTS

THIS CATALOGUE WAS MADE POSSIBLE THROUGH THE GENEROSITY OF MRS. PATRICK HEALY III.

ACKNOWLEDGMENTS

In the summer of 1997, Ann Townsend of the Trust for Museum Exhibitions approached the distinguished scholar of western American art Peter H. Hassrick, now director of the Charles M. Russell Center for the Study of Art of the American West at the University of Oklahoma, to consider curating a century-ending exhibition for the year 2002 encompassing all the masters of Western American art.

R. Andrew Maass, director of the Mississippi Museum of Art in Jackson, who had the idea of assembling a western blockbuster as well, had also approached Peter Hassrick, who in turn suggested contacting Ann. Having worked together previously, Ann and Andy were enthusiastic about working together on the development of *The American West: Out of Myth, Into Reality* and challenging reality by advancing the national tour's inauguration to February 12, 2000, in Jackson.

With the completion of this volume, which accompanies the exhibition, each of us has legions to acknowledge and thank. The Trust for Museum Exhibitions and the Mississippi Museum of Art as well as the tour participants—the Terra Museum of American Art in Chicago and the Toledo Museum of Art—extend sincere thanks and appreciation to the sixty-seven distinguished lenders, both individual and institutional, who put forth remarkable efforts to accommodate the special needs of this exhibition and, with generosity and trust, graciously parted with their precious works of art for an entire year. For all this we are profoundly grateful.

All of us would like to acknowledge our distinguished guest curator, Peter Hassrick, for his keen and illuminating essay establishing the exhibition's important premise (portions of the essay have been adapted from his article "L'arte della frontiera americana," which appeared in the 1993 catalogue for the exhibition *The American West: L'arte della frontiera americana,* held at the Palazzo delle Exposizioni in Rome), his astute selections, and his knowledge of the location of so many of the

exhibition's key works. Without his inspiration and expertise this show would not have achieved its quality and brilliance. Thanks also go to his untiring colleagues, staff, and graduate students who aided in the catalogue research and wrote the vignette essays elucidating the disparate and challenging themes evoked by current art history and politics.

Without Diane C. Salisbury, director of exhibitions for the Trust for Museum Exhibitions and project director for *The American West*, and Katalin Banlaki, exhibitions officer, and their colleagues, there could not have been an exhibition. Their standards of professionalism, charm where that would work, persistence where necessary, and inventiveness when so often called into play successfully produced the 127 loans suggested by Peter Hassrick that produced this stellar assemblage.

This catalogue is the one major element that will long outlive the exhibition tour itself. For the production of this exquisite volume, we express deepest thanks to Diane Maddex, president of Archetype Press; Gretchen Smith Mui, editor; and Robert L. Wiser, designer.

From the Mississippi Museum of Art, special thanks go to the Robert M. Hearin Foundation, whose trust and interest in the museum made the initial and substantial funding for the monumental project possible. Their support has enabled this fifth Annie Laurie Swaim Hearin Memorial Exhibition to come to Jackson. Special acknowledgment is also due the MMA staff and their colleagues, all of whom have played an important role in making the exhibition and tour a success.

Ann Van Devanter Townsend
President, Trust for Museum Exhibitions

R. Andrew Maass
Director, Mississippi Museum of Art

LENDERS TO THE EXHIBITION

Albuquerque Museum, Albuquerque, N.M.

American Heritage Center, University of Wyoming,
 Laramie, Wyo.

American Philosophical Society, Philadelphia, Pa.

Amon Carter Museum, Fort Worth, Tex.

Arizona State University Art Museum, Tempe, Ariz.

Autry Museum of Western Heritage, Los Angeles, Calif.

Bancroft Library, University of California, Berkeley, Calif.

The Beinecke Rare Book and Manuscript Library,
 Yale University, New Haven, Conn.

Buffalo Bill Historical Center, Cody, Wyo.

The Butler Institute of American Art, Youngstown, Ohio

California Historical Society, San Francisco, Calif.

Chicago Historical Society, Chicago, Ill.

Chrysler Museum of Art, Norfolk, Va.

The Corcoran Gallery of Art, Washington, D.C.

Dallas Museum of Art, Dallas, Tex.

Denver Art Museum, Denver, Colo.

Denver Public Library, Denver, Colo.

Desert Caballeros Western Museum, Wickenburg, Ariz.

The Detroit Institute of Arts, Detroit, Mich.

Dover Public Library, Dover, N.J.

Eiteljorg Museum of American Indians and Western Art,
 Indianapolis, Ind.

Fine Arts Museums of San Francisco, San Francisco, Calif.

Fred Jones Jr. Museum of Art,
 The University of Oklahoma, Norman, Okla.

Frederic Remington Art Museum, Ogdensburg, N.Y.

Gerald Peters Gallery, Santa Fe, N.M.

Gilcrease Museum, Tulsa, Okla.

Glenbow Museum, Calgary, Alberta, Canada

The Harmsen Museum of Art, Denver, Colo.

Heckscher Museum of Art, Huntington, N.Y.

Jack S. Blanton Museum of Art,
 The University of Texas at Austin, Austin, Tex.

Jefferson National Expansion Memorial,
 National Park Service, St. Louis, Mo.

Joslyn Art Museum, Omaha, Neb.

Kittredge Art Gallery, University of Puget Sound,
 Tacoma, Wash.

Library of Congress, Washington, D.C.

Mabee-Gerrer Museum of Art, Shawnee, Okla.

Milwaukee Art Museum, Milwaukee, Wis.

Mississippi Museum of Art, Jackson, Miss.

Montana Historical Society, Helena, Mont.

Mrs. J. Maxwell Moran, Paoli, Pa.

Museum of Fine Arts, Boston, Mass.

Museum of Fine Arts, Museum of New Mexico,
 Santa Fe, N.M.

National Gallery of Art, Washington, D.C.

National Museum of Wildlife Art, Jackson Hole, Wyo.

The Nelson-Atkins Museum of Art, Kansas City, Mo.

The New Britain Museum of American Art,
 New Britain, Conn.

The New-York Historical Society, New York, N.Y.

Nita Stewart Haley Memorial Library, Midland, Tex.

Norton Museum of Art, West Palm Beach, Fla.

Oakland Museum of California, Oakland, Calif.

Oregon Historical Society, Portland, Ore.

Arthur J. Phelan, Washington, D.C.

The Philbrook Museum of Art, Tulsa, Okla.

Phoenix Art Museum, Phoenix, Ariz.

Rockwell Museum, Corning, N.Y.

Roswell Museum and Art Center, Roswell, N.M.

Shelburne Museum, Shelburne, Vt.

The Snite Museum of Art, University of Notre Dame,
 South Bend, Ind.

Terra Museum of American Art, Chicago, Ill.

Texas Christian University, Fort Worth, Tex.

The Toledo Museum of Art, Toledo, Ohio

University Art Museum, The University of New Mexico,
 Albuquerque, N.M.

University of Michigan Museum of Art, Ann Arbor, Mich.

U.S. Department of State, Diplomatic Reception Rooms,
 Washington, D.C.

Utah Museum of Fine Arts, University of Utah,
 Salt Lake City, Utah

The Walters Art Gallery, Baltimore, Md.

Washington University Gallery of Art, St. Louis, Mo.

Mr. and Mrs. W. D. Weiss, Jackson, Wyo.

William A. Karges Fine Art, Carmel, Calif.

Yale University Art Gallery, New Haven, Conn.

THE ELEMENTS OF WESTERN ART

Peter H. Hassrick

Since the early 1990s, significant new thinking and abundant academic posturing have brought forward some fresh, not always entirely palatable insights into the subject of America's western art. What was traditionally perceived of in proud, often hyperbolic terms as the art most representative of America's cultural and historical essence became transformed almost overnight into a hapless sociocultural pariah. Painters who had portrayed some of America's most spectacular scenery were suddenly considered suspect for "beautifying" a region whose splendors thus revealed were said to disguise reality and serve little more than mercenary interests. Artists who had focused on the historical genres of the cowboy, the pioneer woman, and Indian life and who had been celebrated as recorders of lifeways previously considered compelling and unique were now reviled for sexist,

racist, and imperialist persuasions. What as a discipline had been rather sleepy and self-satisfied—in fact, generally dismissed as a discipline at all—now heaved under the weight of unprecedented analytical pressure and convulsed from the agonies of unwelcome and unrelenting reinterpretation. In short, the mythic dust from the long western cultural trail that had settled peacefully over several generations of popular elucidation was now kicked up as a malevolent haze, a cloud of cultural pollutants that shamed and defamed American cultural traditions. "Cowboy art," as it is sometimes referred to pejoratively, was no longer allowed to claim a range devoid of discouraging words.

So what is this suddenly transmogrified enigma called "western art," and who were its practitioners? Why was it fixed for so long in the public perception as an esteemed, quintessentially

1. John Mix Stanley, *Chain of Spires along the Gila River*, 1855. Oil on canvas, 31 × 42 inches.
Collection of Phoenix Art Museum, Phoenix, Ariz. Museum purchase with funds provided by the Estate of Carolann Smurthwaite.

national expression only to be dislodged and cast into the quagmire of revisionist doubt and ignominy?

Western art is, in reality, a relatively simple thing to define: it is art that portrays scenes of the region that lies west of the Mississippi River and within the continental United States. The height of its practice occurred over four generations from about 1825 until 1925, coinciding roughly with the region's frontier years. It is typically art produced by European Americans, although Native American practitioners have made important contributions, as have Hispanic artists. As a tradition, western art tends strongly toward the narrative, often endeavoring to recount visually the elements of western history. In fact, the discipline has suffered profoundly because its early students espoused the notion that the validity of the works as art somehow equated with the historicity of the images—that is, the more accurate the portrayal, the better the art. Such thinking created a controversy that continues to arouse contrasting opinions and has tended to marginalize the discipline, separating it from the larger body of American art history. More recently, western art has undergone vigorous scrutiny for its social, political, and psychological contexts, creating a healthy although sometimes contentious debate among critics and aficionados. It has also enjoyed some recognition for unique aesthetic contributions, many of which boldly transcend historical analogue and ideological context to expose purely pictorial or sculptural dimensions.

2. Charles M. Russell, *His Heart Sleeps*, 1911. Oil on canvas, 6⅞ × 11⅞ inches.
Buffalo Bill Historical Center, Cody, Wyo. Gift of the Charles Ulrick and Josephine Bay Foundation, Inc.

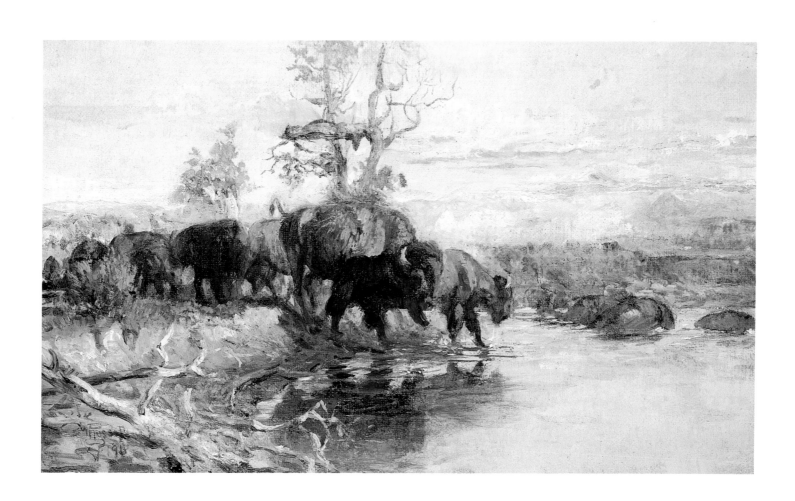

Because many of the artists actually explored the frontier reaches to collect imagery for their work, some have been considered adventurers, almost heroes, in their own right. The sense of quest often set these painters and sculptors apart from others. Artists such as Albert Bierstadt viewed themselves as participants in the frontier experience as well as observers and recorders of it. Some were true explorers, others mere cowboys, and still others Indian advocates and ethnologists. Some were trained as topographers, while others wore soldiers' uniforms. Their experiences found empathetic reflection in their artistic expression. And because no two experiences were the same, no two reflections mirrored a common form. Each interpretation was unique.

The Colorado Territory in 1866 exemplifies this point. That summer at least six artists ventured into the West via stagecoach, each traveling nearly a thousand miles from the railheads in Kansas to Denver and the Rocky Mountains beyond. The conclusion of the Civil War opened a flood of immigration to the West, and artists were among the first wave of enthusiasts who ventured into the unexplored and unexploited domain to test its potential against their particular talent.

Theodore Davis rode the train and then a Butterfield coach to Denver and back in search of imagery for *Harper's Weekly*.

He portrayed scenes he had witnessed or participated in—a buffalo shoot from a train, an Indian attack on a stagecoach, mining camps, and prairie storms—to a public readership across the nation. William Holbrook Beard, although not an artist correspondent, was no less adventuresome. Famed as an animal painter and landscapist, he went west with a travel writer, Bayard Taylor. His mountain landscapes were purported to be fully representative of the grand and exquisite mountain scenery that Colorado featured, while his views of the prairies were equally well received, sometimes evocative of the quiet balances in nature and at other times mindful of the dangers that might be encountered.

James Gookins and Henry Elkins, both of Chicago, spent their summer in the Colorado mountains in search of sublime scenery that might translate into large and, they hoped, sensational works. Thomas Worthington Whittredge, on the other hand, focused on the poetic tones of light and gentle horizontals of the prairies that he enjoyed on his trip west to Denver and Santa Fe. When he painted the front range of the Rockies, he concentrated not on their verticality and awesome splendor but on the peaceful waters that flowed from their source streams and the lacy cottonwoods that graced the rivers' banks.

3. Charles M. Russell, *The Romance Makers*, 1918. Oil on canvas, 23½ × 35½ inches.
The Snite Museum of Art, University of Notre Dame, South Bend, Ind. Gift of C. R. Smith.

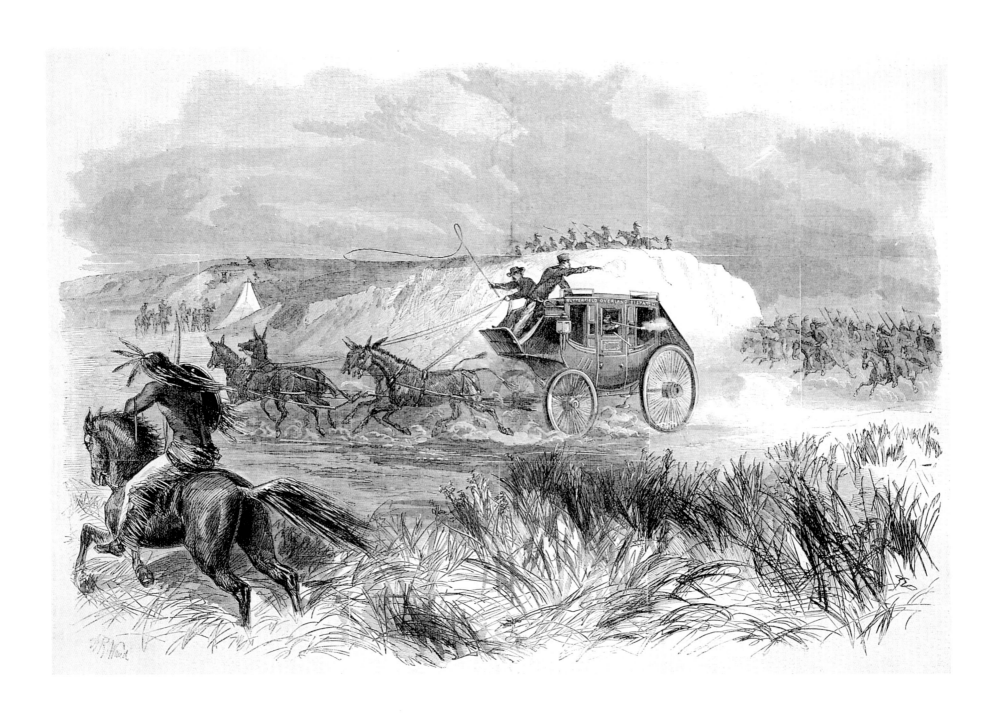

4. Theodore Davis, *On the Plains—Indians Attacking Butterfield's Overland Dispatch Coach*, 1866. Wood engraving, 10¾ × 15½ inches. Collection of Mississippi Museum of Art, Jackson, Miss. Purchase.

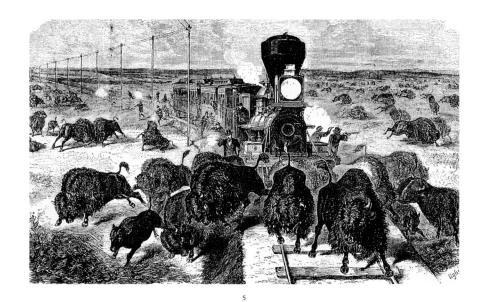

5

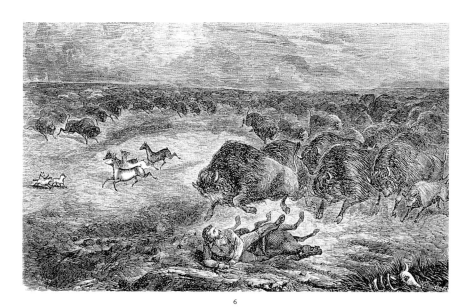

6

5. Theodore Davis, *Shooting Buffalo from the Train,* from *Leslie's Illustrated News,* 1871.
Woodcut, 3⁷⁄₁₆ × 5³⁄₁₆ inches. Buffalo Bill Historical Center, Cody, Wyo.

6. William H. Beard, *A Narrow Escape from the Buffaloes,* 1867. Woodcut, 4 × 6½ inches.
Buffalo Bill Historical Center, Cody, Wyo.

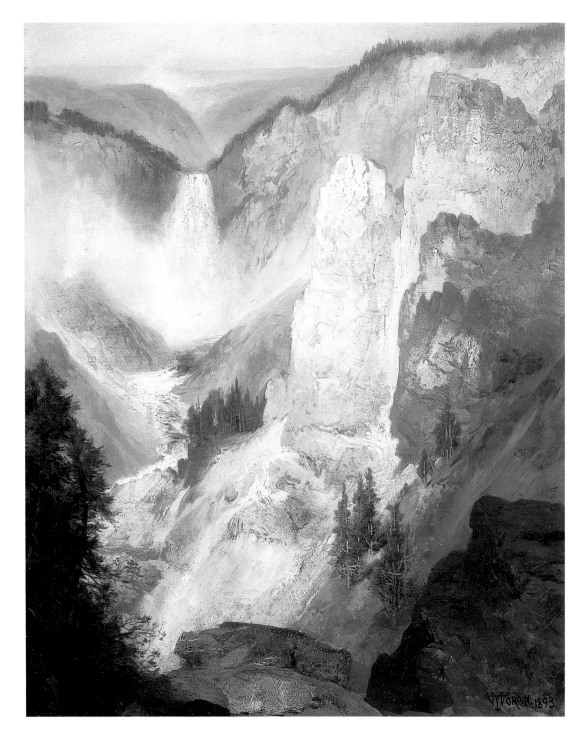

7. Thomas Moran, *Grand Canyon of the Yellowstone*, 1893. Oil on canvas, 19⅞ × 15⅞ inches.
Fine Arts Museums of San Francisco, San Francisco, Calif. Gift of Mr. and Mrs. John D. Rockefeller 3rd, 1979.

8. Henry Elkins, *After the Storm*, 1882. Oil on canvas, 24⅜ × 36¼ inches.
The Harmsen Museum of Art, Denver, Colo. William and Dorothy Harmsen Collection.

This variety in artistic interpretation of the frontier epoch and of the broad reaches of the western domain have given the study of western art a special vibrancy and appeal. But what has garnered the most attention is neither the artists' intriguing adventures nor the variety of their aesthetic interpretations but their renditions of the western myth, inviting scholars and other observers to opine on the credibility, relevance, and stature of their expressions. The sheer power of that myth and its furtherance through the aesthetic medium have proven that while art most often imitates life, life also has a tendency to copy art when that art is sufficiently enshrouded in myth.

One myth of the West, predicated on a fundamental American presumption, is that progress is a positive force. Most western artists were celebrants of the progress myth, manifest in such diverse works as Fanny F. Palmer's *Across the Continent. Westward the Course of Empire Takes Its Way* (figure 50), Henry Farny's *Crossing the Continent—The First Train* (figure 45), William Ranney's *Kit Carson* (figure 52), and Irving R. Bacon's portrayal of Buffalo Bill in *Conquest of the Prairie* (figure 49). In the last work, Buffalo Bill represents the harbinger of civilization, bringing progress west in Conestoga wagons followed by, in due course, railroads, bridges, and cities.

The western myth comprises, in addition, two other fundamental elements. One, suspended from the fringes of the progress myth, is that the West was equivalent to the biblical Garden of Eden. Those western prairies and mountain ranges represented an unspoiled wilderness that afforded an open gateway to wealth, potential exploration, political freedom, and even upward social mobility. Among the many art works that reflected this popular persuasion or elements of it are Bierstadt's *Wind River Country* (figure 20), Paul Kane's *Buffalo at Sunset* (figure 9), and John Mix Stanley's *Chain of Spires along the Gila River* (figure 1). Bierstadt's *Oregon Trail* (figure 47) and Thomas Otter's *On the Road* (figure 14) suggest more than the richness and accessibility of a vast promised land; essentially historical allegories, these two paintings strongly imply a divine

9. Paul Kane, *Buffalo at Sunset*, 1856. Oil on canvas, 16½ × 26⅛ inches.
JKM Collection, Courtesy of the National Museum of Wildlife Art, Jackson Hole, Wyo.

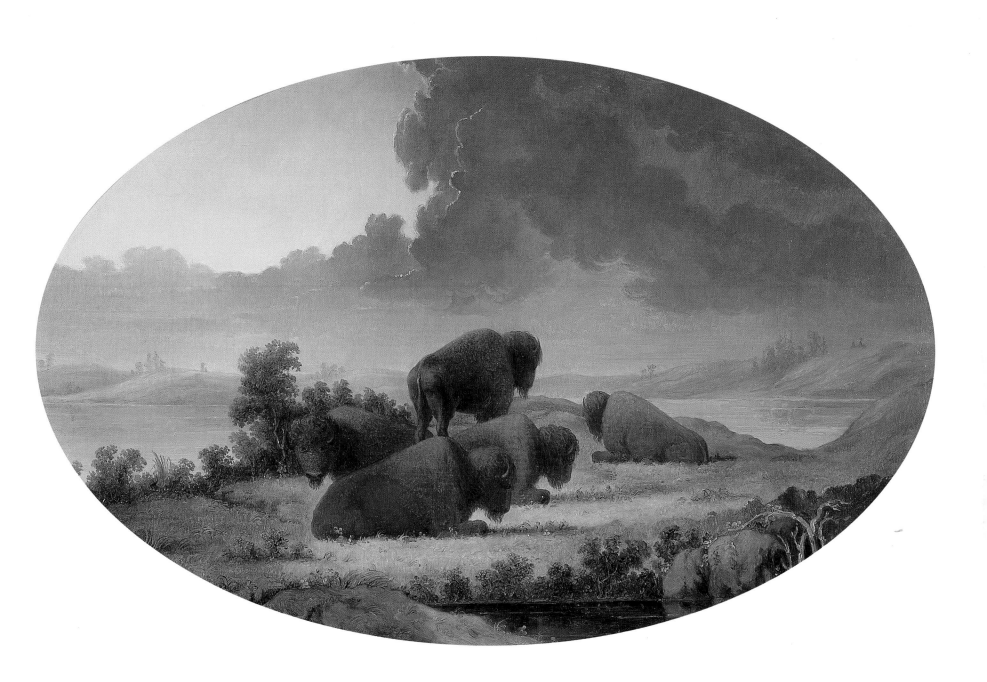

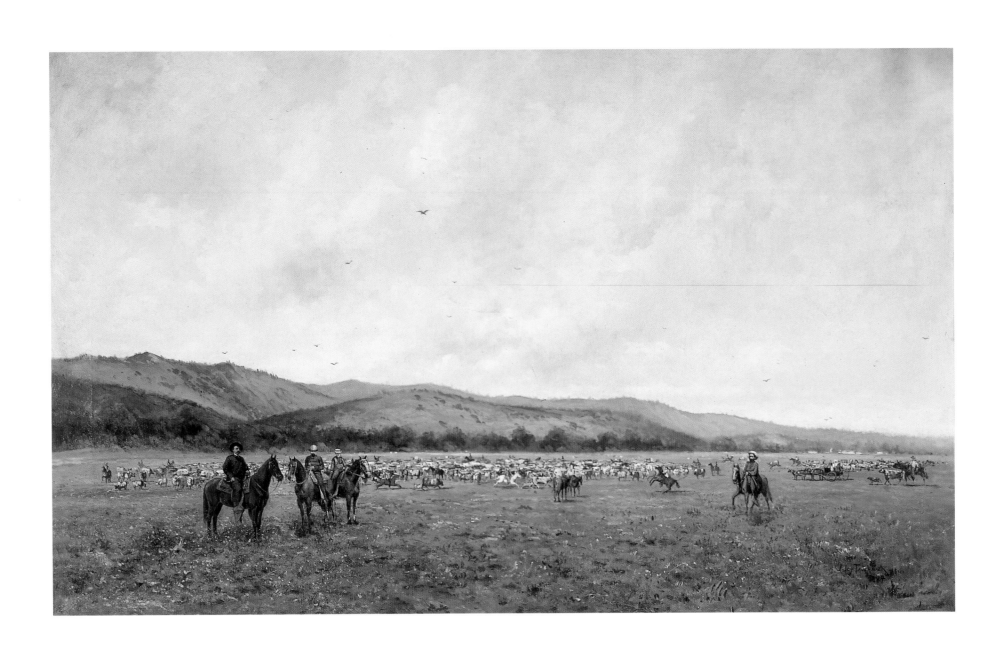

sanction as well as a technological foundation for the notion of Manifest Destiny so interwoven into the European American cultural fabric of the nineteenth century. In paintings such as Charles Deas's *A Solitary Indian, Seated on the Edge of a Bold Precipice* (figure 53), the artist portrays an Indian warrior sitting on a rocky promontory beside a rushing mountain torrent. The sweeping verdant plain in the distance suggests the West's plenitude of natural resources, while the painting's stormy tone and mood, along with such details as the warrior's apparent loss of one moccasin, hint at the impending demise of Indian lifeways. With the Indian out of the picture, the natural resources with which the West abounded would presumably be available for exploitation by the new arrivals to the region: the Anglo-American trappers, farmers, and miners.

A third dimension of the western myth pervading nineteenth- and early-twentieth-century art forms was the West as a masculine domain and the equating of that masculinity with lawlessness, violence, savagery, and the abandonment of social restraint. Such themes were popular in works by Alfred

Jacob Miller and Charles Deas, with their treatments of the fur traders and mountain men in the 1830s, and persisted through the century into the paintings and sculpture of Frederic Remington, N. C. Wyeth, and others. A perfect example is Remington's bronze statuette *The Broncho Buster* (figure 37), in which a male rider conquers a mustang, the metaphorical exemplar of nature's wildness. Through his courage and skill, the rider proves his mettle over the forces of nature and, because he accomplishes his task alone, shows that he requires no assistance from civilization.

These three mythic themes—progress, Eden, and masculinity—were allied with a rich store of iconography and pictorial rhetoric that have formed the core elements of what became popularly denominated as western art. Through the nineteenth century and into the twentieth, this art evolved through four phases: (1) the art of exploration; (2) the frontier experience; (3) landscape grandeur and national identity; and (4) the demise of native cultures and indigenous animals—each of which lasted for roughly a generation.

10. Jules Tavernier, *El Rodeo, Santa Margarita, California,* 1884. Oil on canvas, 30 × 60 inches. Arthur J. Phelan.

THE ARTIST AS EXPLORER

The initial chapter in the history of western art can be called the era of exploratory art. It was primarily a landscape tradition mixing Enlightenment appetites for the picturesque and sublime with the requisite exactitudes of topographical and scientific documentation, as exemplified by the Anglo-American explorers roaming the western reaches in search of new discoveries. Although the first major western expedition, that carried out by Meriwether Lewis and William Clark in 1803–4, did not include trained artists, most later ones did. Stephen H. Long, who came to the Rocky Mountains in 1820, brought not one but two painters as part of his retinue. Titian Ramsay Peale, who had joined the expedition to collect and record natural history specimens, painted some of the first views of antelope and bison on the open prairies and provided pictorial documentation of Indian lifestyles witnessed by the party. Peale's brilliant little sketch entitled *Indian Brave on Horseback* (figure 66) became the prototype for his subsequent depictions of the buffalo hunt and a model for generations of later artists who found that theme emblematic of western life. Peale's associate, Samuel Seymour, was hired to portray landscape views. His precise yet delicate topographical renditions of mountain scenery provided not simply a record of discovery but also a confirmation, through the poetry of the picturesque, of the West's allure and accessibility.

From the 1820s through the middle of the century, such documentary landscape work became common illustrative adjuncts to most U.S. government reports of western expeditions. The largest number of such works appeared in the reports

11. Alfred Jacob Miller, *The Buffalo Hunt,* ca. 1850. Oil on canvas, 38½ × 56½ inches. The Philbrook Museum of Art, Tulsa, Okla. Gift of Lydie Marland in honor of George Marland and Governor E. W. Marland.

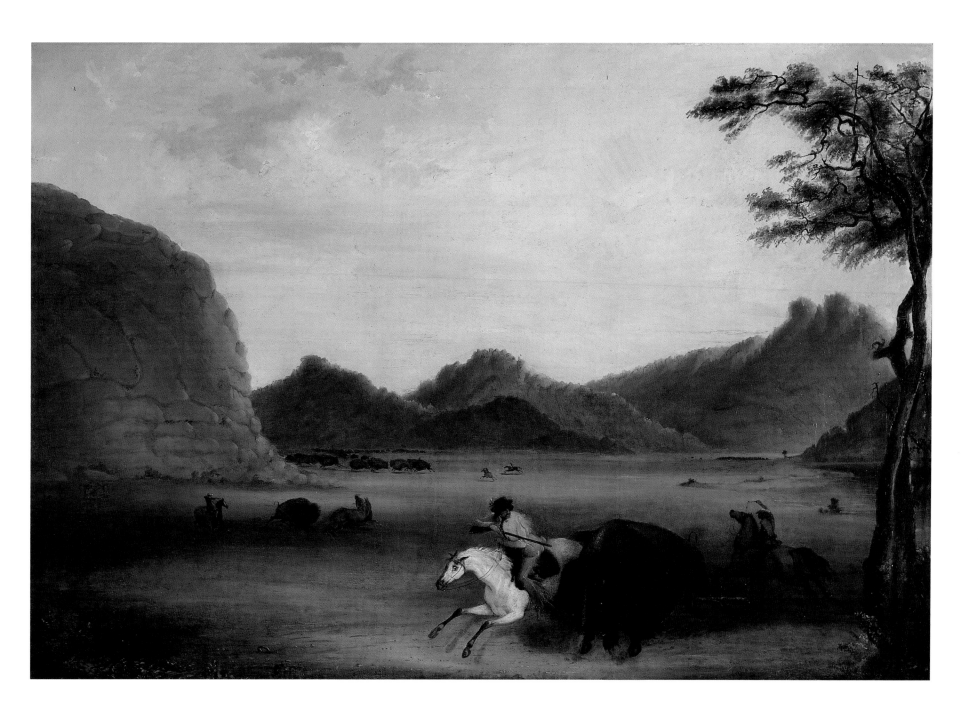

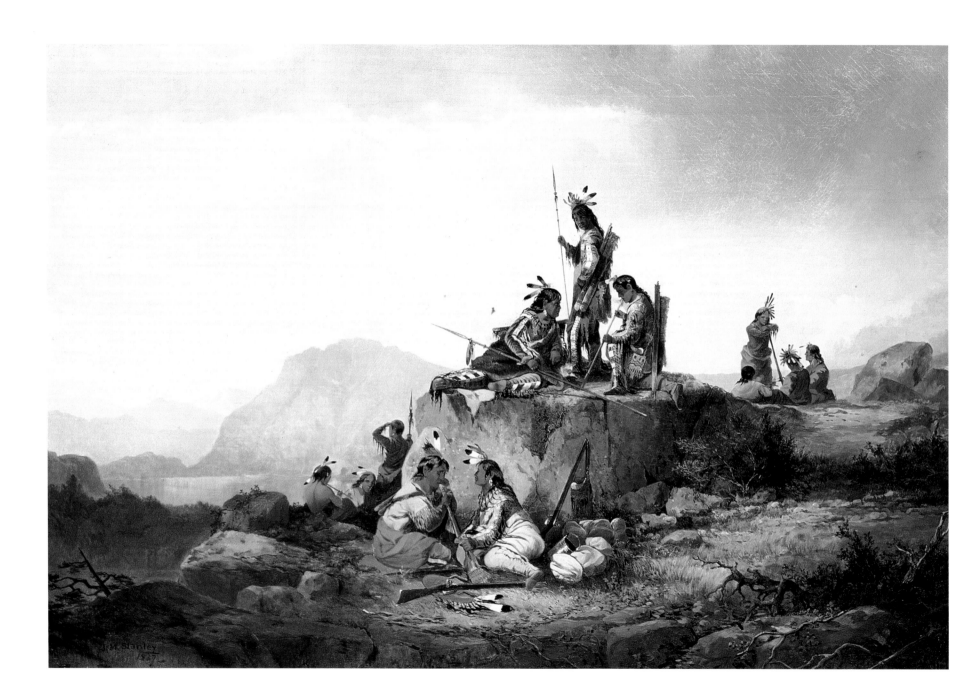

summarizing the findings of multiple expeditions across the West in the 1850s in search of the most viable route for a transcontinental railroad. More than a dozen artists were employed to illustrate the twelve volumes that recounted the findings of those forays. The most prolific of these explorer-artists was John Mix Stanley. His watercolor field study *Fort Union and Distribution of Goods to the Assiniboins* (figure 43) is exemplary of the work he produced on the Isaac Stevens railroad survey, which traveled from St. Paul, Minnesota, to Puget Sound, Washington, in 1853.

Stanley was also part of a small group of artists in the West who sought to assemble what came to be known as Indian galleries, encyclopedic collections of paintings of American Indians that were shown from city to city as traveling exhibitions. These consisted primarily of portraits but also featured scenes of Indian life and landscape views of the regions explored. Fascinated especially by Indian gambling and smoking habits, Stanley returned to these themes in his paintings time and again, especially in his later work. Stanley's Indian gallery, which eventually consisted of more than 150 paintings, was exhibited widely across the United States in the 1850s and 1860s but was tragically lost to a fire at the Smithsonian Institution in 1865.

The most renowned of the Indian galleries was that assembled by George Catlin in the 1830s. It boasted more than six hundred paintings and found its most enthusiastic audiences in Europe, especially England and France. Catlin shared Stanley's interests in landscapes and portraits but enhanced them with a strong quasi-scientific bent. From firsthand observation he not only painted Indian life but also wrote prodigiously and effectively about the subject.

12. John Mix Stanley, *Group of Piegan Indians*, 1867. Oil on canvas, 27 × 41 inches. Denver Public Library, Denver, Colo. Western History Collection.

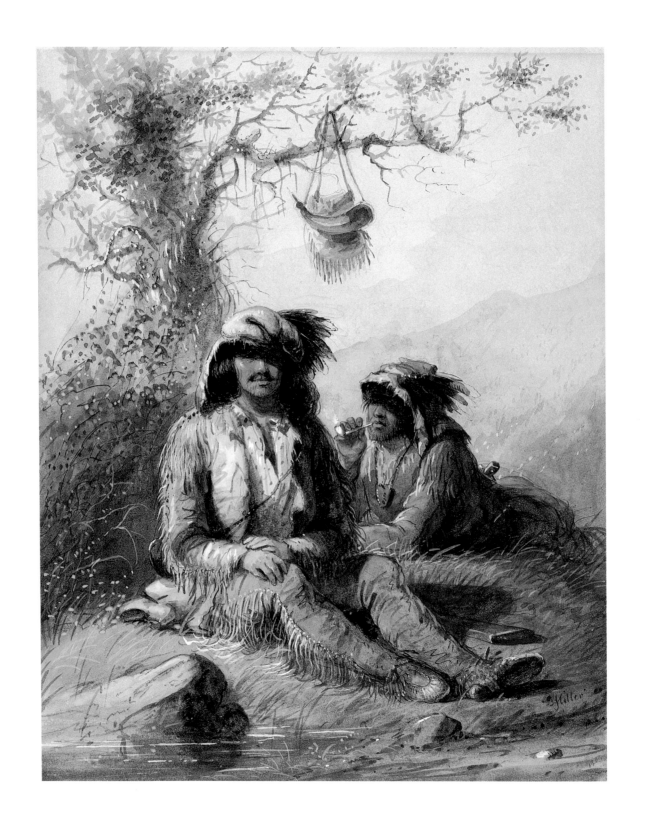

NARRATIVES OF THE FRONTIER EXPERIENCE

Whereas Stanley, Catlin, and other artists early in the nineteenth century were infatuated with Indian life, there evolved among the next generation of artists, during the mid-1800s, a school of narrative paintings that was fundamentally Anglocentric. Most of these works were genre scenes of pioneer life on the frontier. A few ascend to the level of history painting, at the time considered a more lofty pursuit than genre, portrait, or landscape painting.

Within these narrative pictures a number of dominant themes prevailed. Some repeated the mythic concepts discussed earlier, while others provided fresh, new insights. Many of the midcentury genre artists presented the West as a redemptive experience, a place that was apart from the seemingly degenerate East and that could, by virtue of its innocence, provide for a regenerated community. Some modern scholars have also ascribed to this vision of the West as a barren but dangerous wilderness that required conquering and civilizing. This notion fits comfortably within the progress myth that established a foundation for the precepts of Manifest Destiny. Conquest was celebrated and exalted, whether it was a function of the democratic process through the actions of the common man or a result of progress and evolving technologies such as the railroads. In both cases, progress seemed to encounter few insurmountable impediments, from either indigenous cultures or natural barriers such as mountain ranges and deserts, and eventually became the hallmark of national identity, a perceived moral and spiritual victory for the Anglo-American people.

The frontier experience nurtured the democratic system, according to later historians such as Frederick Jackson Turner,

13. Alfred Jacob Miller, *Trappers*, 1858. Watercolor, 12 × 9 inches. The Walters Art Gallery, Baltimore, Md.

and the common man, as a representative of the democratic system, found a welcome place in the canvases of the genre and history painters. The frontiersman as a folk figure rapidly assumed heroic proportions. In particular, the mountain man and hunter attained epic dimensions. Having escaped the constraints of eastern society by living in harmony with the western wilderness, these otherwise pedestrian trappers were identified as ideal, liberated men.

Such characters inhabiting that wilderness stage produced rich material for the evolving narrative tradition. Some of the pictorial anecdotes that unfolded portrayed a spiritual and cultural bond between native peoples and the Anglo-American intruders. Trappers' marriages to Indian women was a commonly depicted scene, especially in the works of Alfred Jacob Miller, who produced multiple variations on the theme.

Other artists concentrated on the fractious results of cultural intercourse. These depictions, customarily ladened with ethnocentric biases weighted against the Indians, conjured up adventure, danger, and life-or-death scenarios.

Although some of the artists who worked in the narrative genre never stepped west of the Mississippi River, most did. Many who actually visited the frontier in those years did so in search of personal adventure as much as for scenes to preserve on canvas. They perceived themselves as being as heroic as the epic subjects they assigned themselves to paint. When John Mix Stanley arrived at the camp of the Blackfoot Indians on the upper Missouri River in 1853 and found that they were not out hunting buffalo as he expected, he organized a hunt himself. In this way he could not only document the activity but also participate directly in the frontier adventure.

14. Thomas P. Otter, *On the Road*, 1860. Oil on canvas, 22 × 45 inches. The Nelson-Atkins Museum of Art, Kansas City, Mo. Purchase: Nelson Trust.

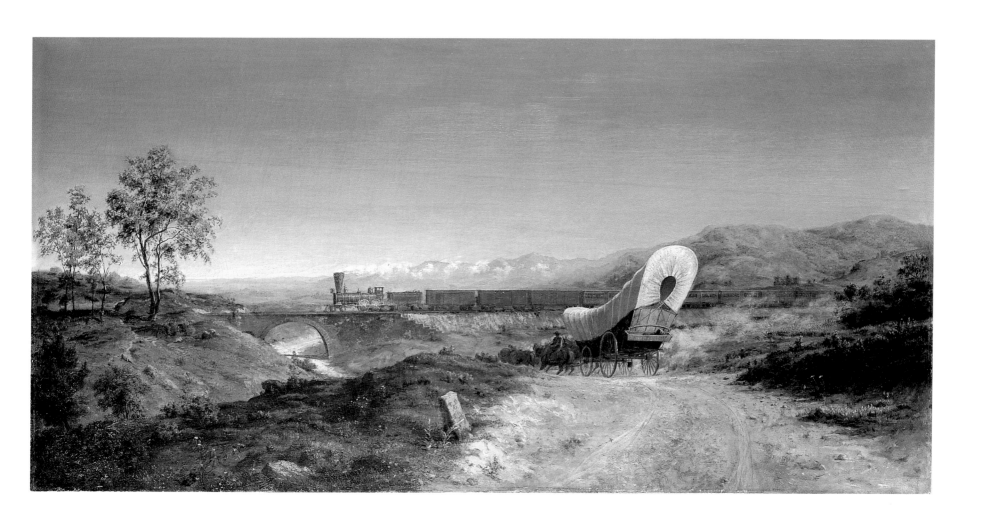

15. Alfred Jacob Miller, *Trapping Beaver*, 1858. Watercolor, 9 × 14 inches. The Walters Art Gallery, Baltimore, Md.

16. Alfred Jacob Miller, *The Wind River Chain*, 1859–60. Watercolor, 8⅝ × 12½ inches. The Walters Art Gallery, Baltimore, Md.

LANDSCAPE AS A VISION OF NATIONAL IDENTITY

The third phase of western art occurred after the Civil War in the 1860s and 1870s. This phase represented essentially an abandonment of the genre and historical themes for less humanistic although no less compelling interpretations of the western landscape. Painters such as Albert Bierstadt, born and trained in Germany, and Thomas Moran, born in England and influenced by English painters, dominated the scene during these years. Just as the earlier historical and genre art had been influenced by English sporting art and tenets of German academic painting, the landscape pictures of these later decades must credit European conventions learned from John Ruskin, J. M. W. Turner, and a host of German landscapists who celebrated a highly romanticized, rather theatrical interpretation of the natural world.

Fresh from classes at the Dusseldorf Academy and painting excursions in the Bernese Alps, Bierstadt visited the West for the first time in 1859 with a U.S. government expedition searching for shortcuts along the Oregon Trail. The Wind River range of the central Rockies captured his attention, and he explored its awesome profile with the same romantic fascination that had made earlier painters interested in the Native Americans and the mountain men.

Like many artists of his day, Bierstadt was looking for scenes that would exemplify the burgeoning greatness of the relatively young American nation, and the Rockies provided a subject as grand as any the artist had witnessed in the Alps. In works such as *Wind River Country* (figure 20) he captured the western mountains as a metaphor for that dream of ascendant national stature. The Rockies and the Sierras were symbols of America's potential, and he exposed their force in the dynamic of his grand creative expression. But he also brought to these mountain scenes the conventions of European painting popular at the time. The theatrical, almost baroque compositions of snow-clad peaks and billowing clouds offset by exotic dramas being acted out on a stagelike foreground became a hallmark of Bierstadt's mature work.

In 1871, twelve years after Bierstadt first visited the central Rockies, Thomas Moran arrived in the upper Yellowstone Canyon region farther to the north, traveling with the legendary explorer and geologist Ferdinand V. Hayden. The

17. Thomas Moran, *Shivas Temple, Grand Canyon*, 1892. Watercolor, 5 × 8 inches. Jefferson National Expansion Memorial, National Park Service, St. Louis, Mo.

Shivar Temple

T. Moran

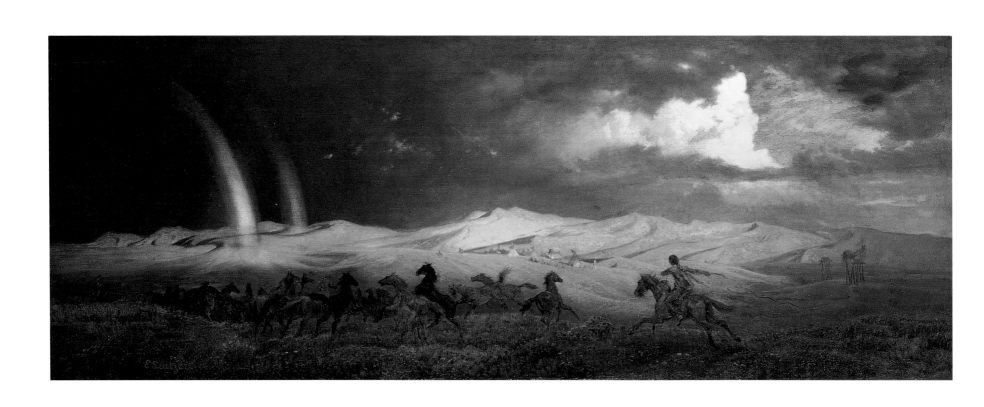

beauty of the area inspired his greatest work—paintings that, like Bierstadt's, conveyed a nationalistic message. Shortly after the Hayden expedition's return to the East the following year, Congress designated Yellowstone the world's first national park. Again, the western wilds became a symbol of America's Manifest Destiny, its intention to control through the exercises of exploration, art, and political mandate even the deepest, most impenetrable recesses of the continent.

The Yellowstone experience transformed the way in which Moran viewed nature and color. Never had he seen either so beautifully or provocatively presented. Fortunately, he was prepared for the task of translating those scenes into art. Moran's studies of the landscapes of the English artist J.M.W. Turner had readied him for handling the profusion of color, and John Ruskin had taught him to synthesize the manifold details of nature into an ideal beauty. Paintings such as *Lower Falls of the Yellowstone* (figure 98) illustrate the successful union of diverse art traditions and unique natural themes in producing powerful aesthetic and political statements of cultural and environmental determinism brilliantly wed. Moran's images were distributed widely in government reports and as popular prints.

At the close of his career, Bierstadt attempted to establish a bridge between western landscape and history painting. By the 1880s the landscape alone was insufficient for Bierstadt's grand expression: he wished to add the power of narrative to the equation. To that end, he produced in 1889 his famous *Last of the Buffalo* and multiple variations on the buffalo theme, such as *Indians Hunting Buffalo* (figure 106). With these works he turned from optimistic expressions of a spectacularly bountiful land to a provocative statement of finale. Here he introduced the metaphor of demise, the Rousseauian theme of an exotic, other world—the West— shrouded by the pale of fatalism, the extinction of native cultures and native species. By this time the West had been exploited to such an extent that Native Americans were reduced to captives barely surviving on reservations, while once-abundant animals had been hunted to the point of near extinction. The North American herds, once numbering in the tens of millions—as seen in William Jacob Hays's monumental depiction *The Stampede* (figure 75) and the accompanying preliminary field sketch—could now be counted in the low hundreds.

18. Emanuel Gottlieb Leutze, *Prairie Bluffs at Julesburg, South Platte, Storm at Sunset*, 1863. Oil on canvas, 18 × 48 inches. U.S. Department of State, Diplomatic Reception Rooms, Washington, D.C. Funds donated by the Honorable John McCone and Mrs. McCone.

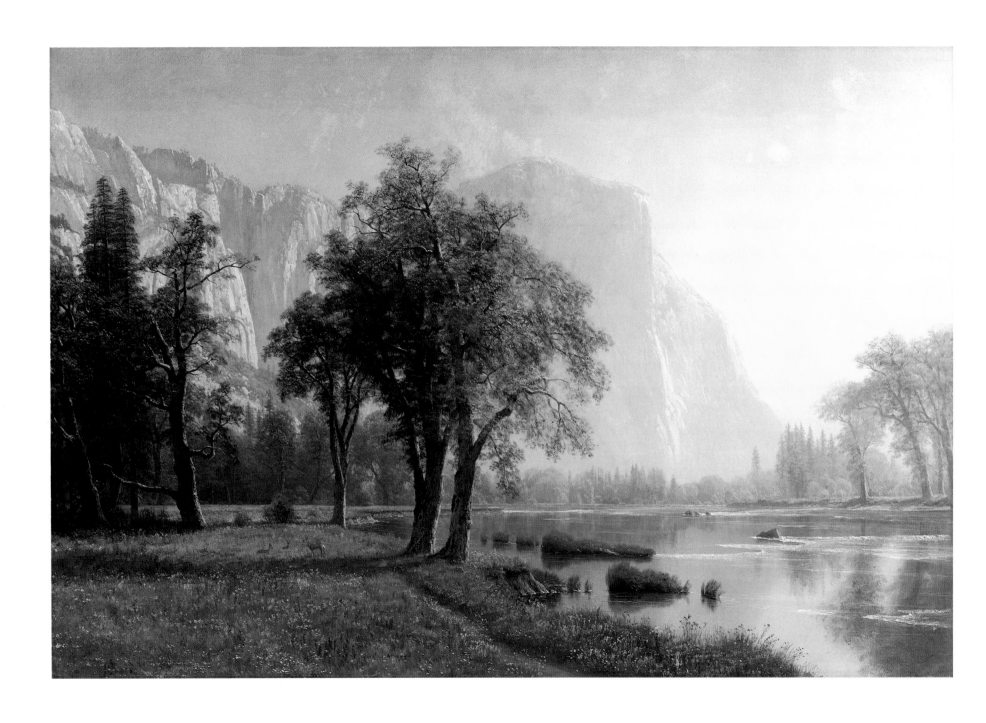

19. Albert Bierstadt, *El Capitan, Yosemite Valley, California*, 1875. Oil on canvas, 32³⁄₁₆ × 48¹⁄₈ inches.
The Toledo Museum of Art, Toledo, Ohio. Gift of Mr. and Mrs. Roy Rike, Toledo.

20. Albert Bierstadt, *Wind River Country,* 1860. Oil on canvas, 30 × 42 inches.
Denver Art Museum, Denver, Colo.

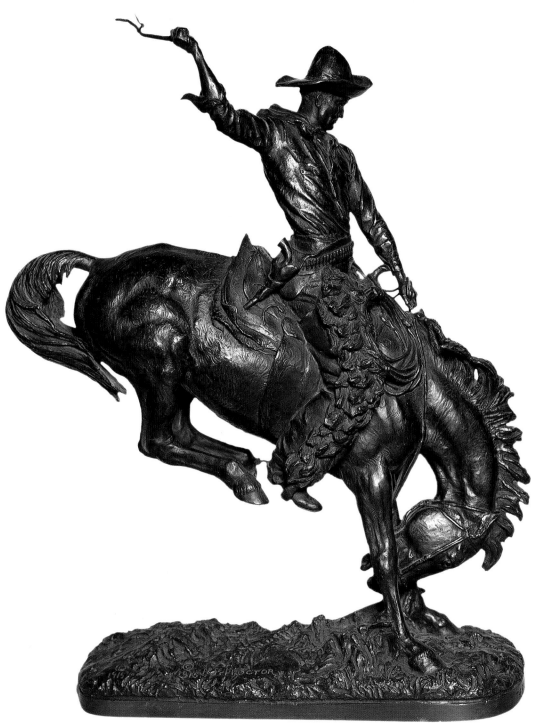

21

22

Bierstadt's switch to allegorical narrative interpretations of western life was heartily adopted by the next generation of western artists, a group of painters and sculptors who would carry the traditions into the twentieth century. Probably the most popular artist of this fourth phase of western art was Frederic Remington, who knew from the beginning of his career that the scene he set out to depict was, like the bison, quickly disappearing. As a consequence, much of his work is epic in scale and fatalistic in temper. *The Last Lull in the Fight* (figure 104), painted the same year as Bierstadt's *Last of the Buffalo,* won international acclaim for the young Remington, garnering a silver medal at the 1889 Paris Exposition.

Like Bierstadt's piece, Remington's symbolized the close of the western epoch. Where Samuel Seymour's early views of the Rocky Mountains had invited the viewer to enter the scene and take advantage of the limitless expanse and promise, Remington's depictions some seventy years later are broadly unwelcoming. Gone is the promise. Only a hint of Darwin's survival of the fittest remains to suggest that some element, if sufficiently tough, will persevere. Similar later portrayals of the subject, such as *Rounded Up by God* (figure 105) by Remington's contemporary Henry Farny, depict the Anglo-American vanquisher as victim. The garden has disappeared. The cowboy is left fighting for empty desert, a land just as foreboding as his phantom adversaries, the Indians.

This final saga in the historic western epoch centered on the life of the cowboy, glorifying his relatively short episodic career in much the same way that earlier artists such as Alfred Jacob Miller had revered the life of the mountain man. The cowboy ultimately assumed the prescribed attributes of that earlier folk hero. Ostensibly self-reliant, free spirited, and hard working, he was richly imbued with romantic aura. His was a world removed from social restraint, an exotic grassland stage on which he acted out chivalric adventures or man-to-man contests of strength and will, at least as depicted by Remington.

21. Alexander Phimister Proctor, *Buckaroo,* 1915. Bronze, 28 × 23 × 9 inches. Oregon Historical Society, Portland, Ore.

22. Charles M. Russell, *Jim Bridger,* ca. 1925. Bronze, 14⅜ × 13 × 9¾ inches. Amon Carter Museum, Fort Worth, Tex. (1961.70).

Remington's precise delineation of detail—often accurately portrayed, sometimes not—evinced a style well suited to his cowboy art. While on assignment for magazines such as *Harper's* and *Century,* Remington, an active artist-correspondent, enjoyed participating in the scenes that he pictured or at least observing them firsthand, and he traveled widely to expose himself to the waning frontier ambiance. His images, most conceived as illustrations for popular journals of the day, were published in such profusion that, in reality, he as much shaped the West in the public mind as recorded it.

In the last years of his life, Remington turned toward impressionist and postimpressionist idioms as a form of expressing his vision of western life. *Ghosts of the Past* (figure 108), with its soft contours and resplendent but harmonious light, is an example of his late efforts in the impressionist mood. Little changed from his earlier paintings was the subject: resolute cowboys riding the high plains.

Another artist who has been lauded and widely appreciated for his pictorial interpretations of the Indian and the cowboy is Charles M. Russell. Like Remington, Russell imbued his work with a hint of fatalism but was generally more philosophical, regarding the past, including the history of the West, as fundamentally redemptive. While Remington, as an artist-correspondent, celebrated the importance of the present, Russell believed that the past, as morally superior, might redeem the actions of the present. Eschewing progress, he championed the Indian as the hero of an innocent past time. His heavily symbolic painting *His Heart Sleeps* (figure 2) suggests the pathos of the declining Indian cultures but commensurately commends the powers of nature to heal and endure despite the ravages of time. Although Russell's style underwent several transformations before his death in 1926, his interpretations of western scenes and life changed little.

Russell's contemporaries Alexander Phimister Proctor and William Robinson Leigh tended to revere the same bygone themes that portrayed the Indians as a grand but vanished race. Although Leigh's painting *Lullaby* (figure 85) speaks to the continuity of traditions and future generations of Native Americans, it is also tinged with an aura of remembrance and nostalgia. A sense of loss seems to prevail.

23. Frederic Remington, *Indians Simulating Buffalo,* 1908. Oil on canvas, 26⁵⁄₁₆ × 40⅛ inches. The Toledo Museum of Art, Toledo, Ohio. Gift of Florence Scott Libbey.

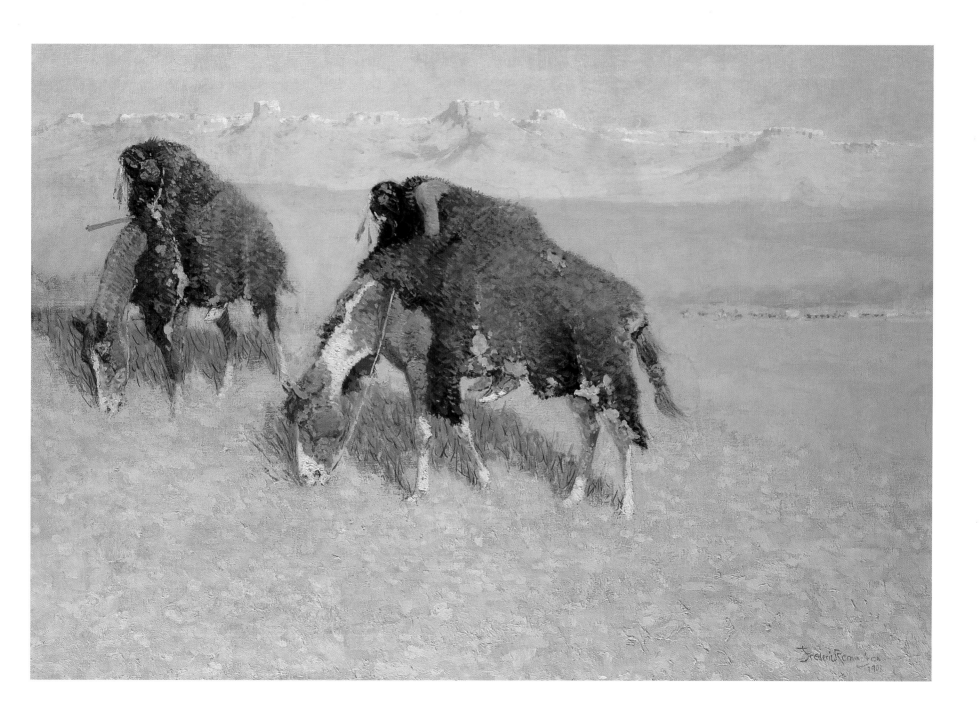

Beginning in the second decade of the twentieth century, a group of New Mexico painters trained in Europe's Beaux-Arts academies sought to record southwestern Indian life as a vital although fundamentally decorative force. Attempting to avoid pictorializations of Indians as either spirited warriors, as in Charles Russell's *Medicine Man* (figure 111), or as a defeated people left only with the possibility of a grand gesture of resignation, as in Cyrus Edwin Dallin's *Appeal to the Great Spirit* (figure 103), these artists claimed new ground. They strove to reveal living, breathing realities rather than symbols of abnegation, stoicism, or aggression. E. Irving Couse's *Indian Hunter* (figure 24) appealed to audiences of the day because of its formal, academic presentation, the obvious reverence with which the artist regarded Indian forms, and the celebration of everyday life. Wishing to evince the quiet, inner essence of western native peoples, Couse generally imbued his canvases with poetic introspection. Yet even here, with the scene washed in autumnal light, a sense of passing is evident.

One of the leaders of the Taos branch of this group, Joseph Henry Sharp, dubbed by his associates as "the anthropologist" because of the matter-of-fact nature of his work, documented scenes from Pueblo and Northern Plains Indian life that celebrate long-held, sustained tribal traditions. His *Prayer to the Spirit of the Buffalo* (figure 122) is both a spiritual reverie and a record resulting from astute first-hand observation.

Other Taos artists were somewhat more daring in their presentations, willing to skirt both academic formulae and documentation without sacrificing vitality. An example was E. Martin Hennings, who in such works as *Riding Through the Sage and Cedar* (figure 123) sought much the same poetic interpretation of the Indian as did Couse while adding pictorial grace and fluidity informed by Art Nouveau elegance. Yet the colorful blankets and bold physical, frontal positioning of the figures in many of his paintings show the artist's clear commitment to presenting native people with a strongly individual as well as broadly cultural presence.

For many painters and photographers, the southwestern experience was transformative. Robert Henri had painted and

24. E. Irving Couse, *Indian Hunter,* ca. 1916. Oil on canvas, 30¼ × 64½ inches. Arizona State University Art Museum, Tempe, Ariz.

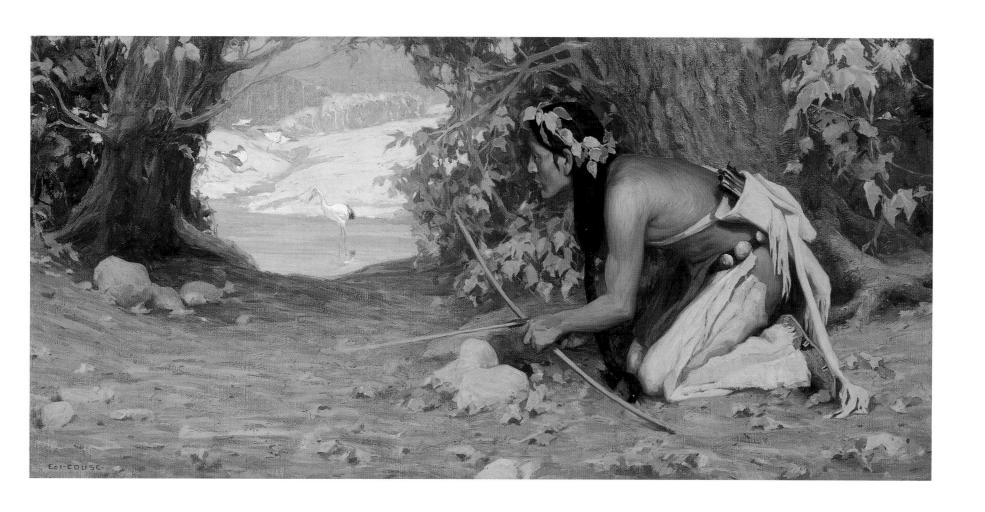

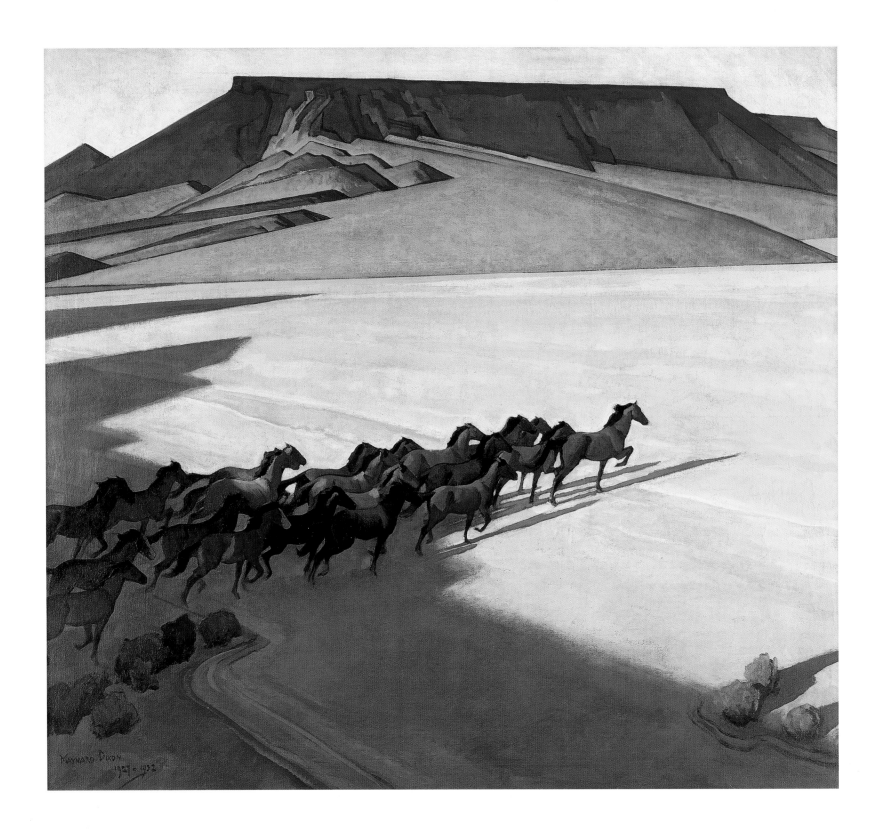

taught realist portraiture in Philadelphia, Paris, and New York for fifteen years before coming to New Mexico in 1916. Partly in response to the quiet patterned life of Pueblo people and the powerful abstract designs of their pottery and blankets, Henri's portraits take on a more faceted, less naturalistic appearance. His *Ricardo* (figure 119), one of more than half a dozen paintings of this young man from San Ildefonso, shows this stylistic change. Thus for Henri, the West provided an opportunity to explore not only new subjects and their spiritual qualities but modernist tenets as well.

Like Taos, Santa Fe too was a mecca for numerous modernist painters in the 1920s. Ernest L. Blumenschein, a founder of the Taos Society of Artists, was only mildly modernist in his own works, such as *Mojave Desert* (figure 26), but encouraged acceptance of a wide variety of interpretations. When the expressionist painters William P. Henderson and Jozef Bakos, whom he had sponsored, were not openly welcomed by his Taos colleagues, Blumenschein abandoned the group to form a more liberal association in nearby Santa Fe, the New Mexico Painters. Bakos enthusiastically explored the changing light and mood of the New Mexico landscape. His *Springtime Rainbow* (figure 27) is both dramatically picturesque and boldly experimental. His work, along with that of his Santa Fe associate B.J.O. Nordfeldt, was reminiscent of French modernism, especially in the use of structured planar underpinnings to express natural form. Nordfeldt's *Thunderdance* (figure 118) reveals a powerful sympathy between the painterly imperatives of the French painter Paul Cézanne, the rhythms of Native American ceremony, and the rich colorations of the New Mexico landscape. Like Henri's portraits, it also resonates spiritually.

Combining the geometric essence of nature with the kinetic force of western life was a special talent of another painter of the southwest, Maynard Dixon. In his painting *Wild Horses of Nevada* (figure 25), mustangs surge forth from canyon shadows into the desert glow. Their energies, harnessed slightly by the formality of Dixon's cubist realist style, invigorate the austerity of the awesome space into which they intrude. Dixon's modernist vision of the West was later complemented by that of other artists including Marsden Hartley and John Marin.

25. Maynard Dixon, *Wild Horses of Nevada*, 1927. Oil on canvas, 40 × 50 inches. William A. Karges Fine Art, Carmel, Calif.

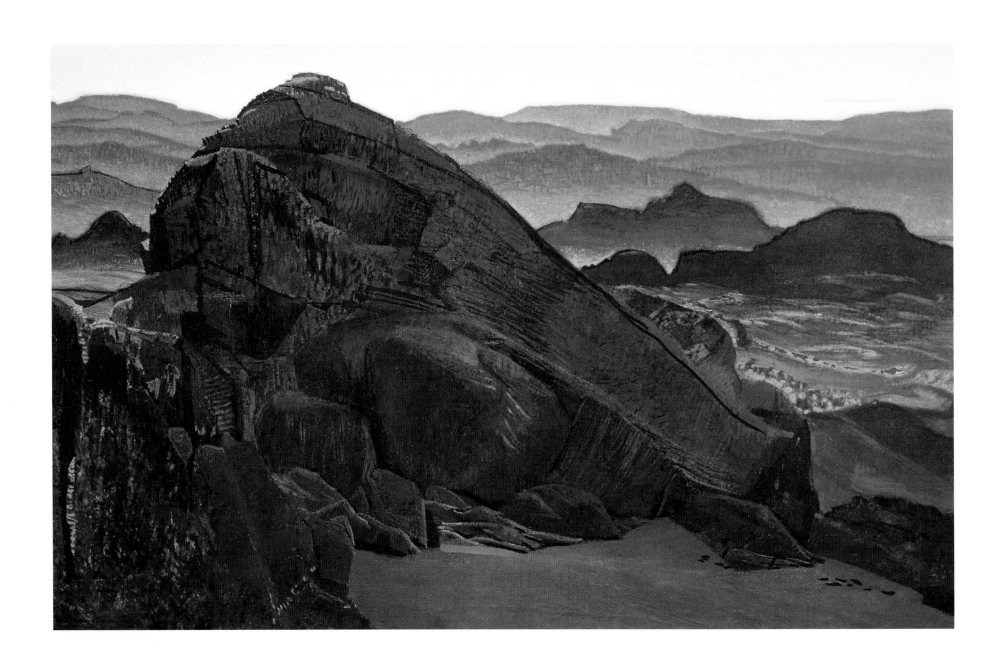

26. Ernest L. Blumenschein, *Mojave Desert*, n.d. Oil on canvas, 32½ × 50¾ inches.
Gilcrease Museum, Tulsa, Okla.

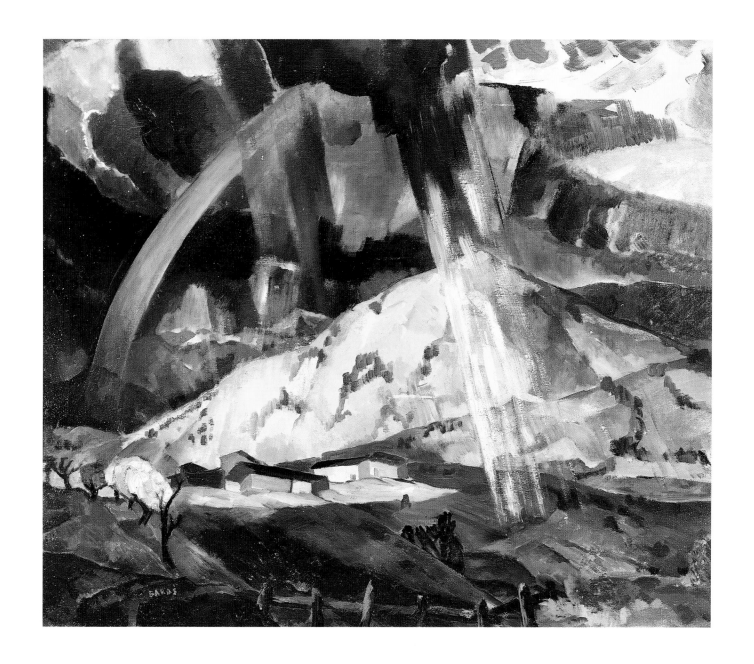

27. Jozef Bakos, *The Springtime Rainbow,* 1923. Oil on canvas, 29½ × 35¼ inches.
Museum of Fine Arts, Museum of New Mexico, Santa Fe, N.M. Gift of the artist in honor of Teresa Bakos.

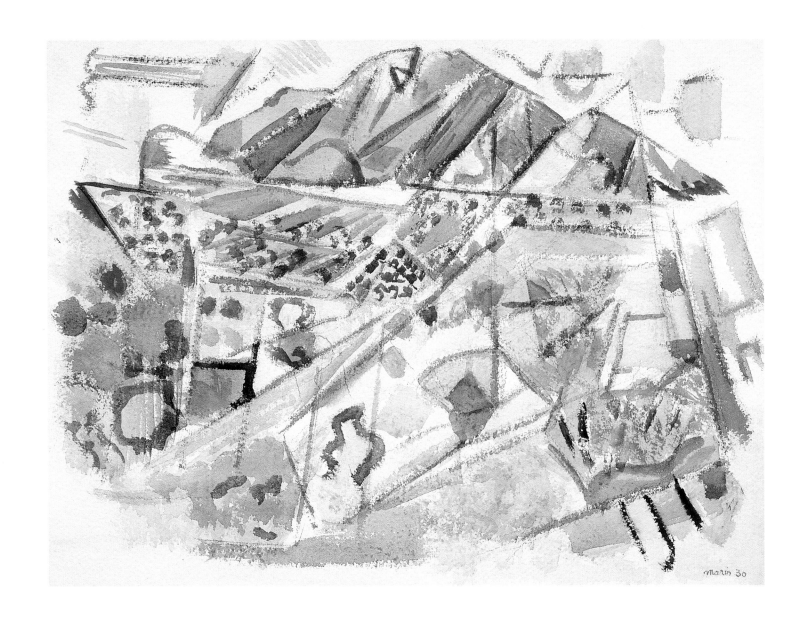

28. John Marin, *Region of Taos, New Mexico*, 1930. Watercolor on paper, 15¼ × 20¾ inches.
Courtesy of Gerald Peters Gallery, Santa Fe, N.M.

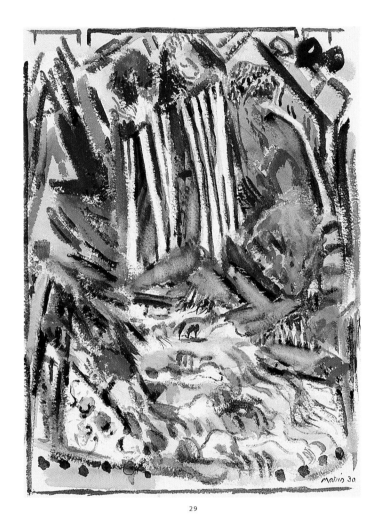

29

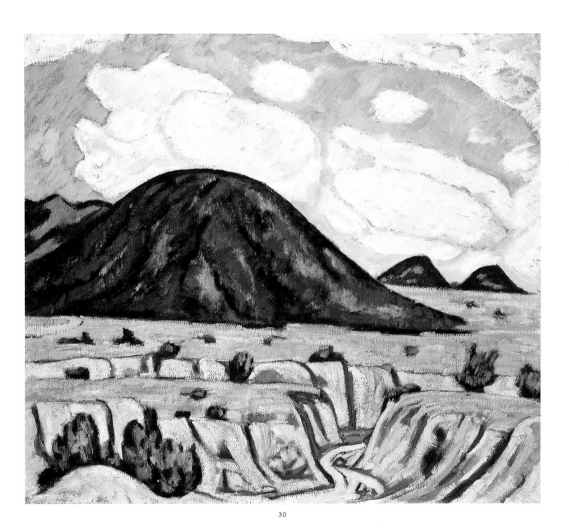

30

29. John Marin, *Aspens and the Roaring Hondo, New Mexico*, 1930. Watercolor on paper, 20¼ × 15¼ inches.
Albuquerque Museum, Albuquerque, N.M.

30. Marsden Hartley, *Landscape: New Mexico*, 1920. Oil on composition board, 25½ × 29¾ inches.
Collection of Roswell Museum and Art Center, Roswell, N.M. Gift of Ione and Hudson Walker.

IN RETROSPECT

A review of these western artists and their works would reveal how easy it is to romanticize these productions and their creators as servants of nationalistic imperative. The western experience, perceived for generations as a quintessentially American phenomenon, played openly into the hands of artists who wished to find recognition for making a contribution to their national art scene. They adopted, quite naturally, the sentiments of their times as well as the contemporary value systems, extrapolating from them perspectives that served to govern their interpretations of the quickly evolving frontier.

Today, some of those sentiments and values are difficult to justify, much less excuse. The myth of linear progress led to gross exploitations of what appeared to be bountiful, limitless natural resources but turned out to be rather fragile, delicately balanced, frequently nonrenewable natural assets. Cultural clashes resulted in the desecration of once proud and self-reliant native peoples. The western railroads, which promised industrial might and political solidarity, also spelled disaster for the huge herds of bison that once roamed the plains. And the bonanza of reckless waste that accompanied the early cattle and mining industries ravished the land, depriving it of much of the beauty that so captured the fancy of artists and their audiences in the first place.

The ironies exposed here are multiple and the artists, by facilitating or enhancing the popularity of those sometimes misguided value systems, are as culpable as any of the players in the frontier drama. Russell extolled the cattlemen, Bierstadt and Moran served railroad interests, and Miller romanticized the fur seekers who overtrapped most of the Rockies' rivers and streams.

To excuse the prodigality of the nineteenth century would be beyond reproach today. Yet to cast only an inimical eye in that direction serves little purpose either. The artists of the West accommodated their society's needs and tastes, for good or for evil, and their own imaginations, sometimes with facts and more often with fancy. In the effort to appreciate western history and understand the evolving artistic traditions that it nurtured and that in turn nurtured it, their work can be savored today.

31. Stuart Davis, *New Mexican Gate,* 1923. Oil on linen, 22 × 32 inches.
Collection of Roswell Museum and Art Center, Roswell, N.M. Gift of Mr. and Mrs. Donald Winston and Mr. and Mrs. Samuel H. Marshall.

Since the journeys of Lewis and Clark, the popular notion of the western United States has been nurtured by dual, contrasting perspectives. One, a romanticized view of a land filled with deep canyons, towering mountains, and savage animals, was perpetuated by the West's wild and beautiful topography. The western expanse with its stunning landscapes was seen as remote, untamed, and unsullied—forbidding yet inviting for the brave and wealthy in search of new and exciting adventures. A second, more practical perspective viewed the West, its land and its natural resources, as commercial real estate, ready to be utilized for all its worth. These divergent perspectives are reflected in the works of Thomas Moran and James Earl Taylor.

Moran's painting *The Cliffs of Green River, Wyoming* (figure 34), portrays the lush, serene western landscape of the Green River. Enveloping the mountains and buttes with a warm, sunny light, he emphasized the colors of the land and created an idyllic setting, breathtaking in its beauty. In the foreground a group of Indians ride by, imbuing the scene with a sense of exoticism and drama. Moran has carefully chosen the wondrous shapes and strange beings, balancing a landscape view with a human element.

At the other end of the spectrum is Taylor's *Green-River* (figure 32), which in its matter-of-fact presentation and reduced scale differs greatly from Moran's romantic view. Using the medium of engraving, Taylor effects a documentary air, creating a realistic view of westward expansion and commerce. Although Taylor's subject is the same as Moran's, the tone of the scene changes when the rugged landscape is framed by a steel bridge on one side and buildings and chimneys on the other, creating a domestic composition that contrasts with Moran's more exotic scene. The vertical drama of Moran's view has been replaced by a level, compositionally stable line of railroad tracks symbolizing commerce and settlement rather than romantic splendor.

Moran's picturesque paintings captured the essence of what was believed to have been the unknown West, a land untouched by "civilized man." Taylor's portrayals are simply captured realities of an already civilized West. Both images accomplish the same goal: attracting easterners to venture west and experience, if not inhabit, the land.[1] *Donna Davies*

32. James Earl Taylor, *Green-River,* 1882. Woodcut, 3½ × 6 inches. Buffalo Bill Historical Center, Cody, Wyo.

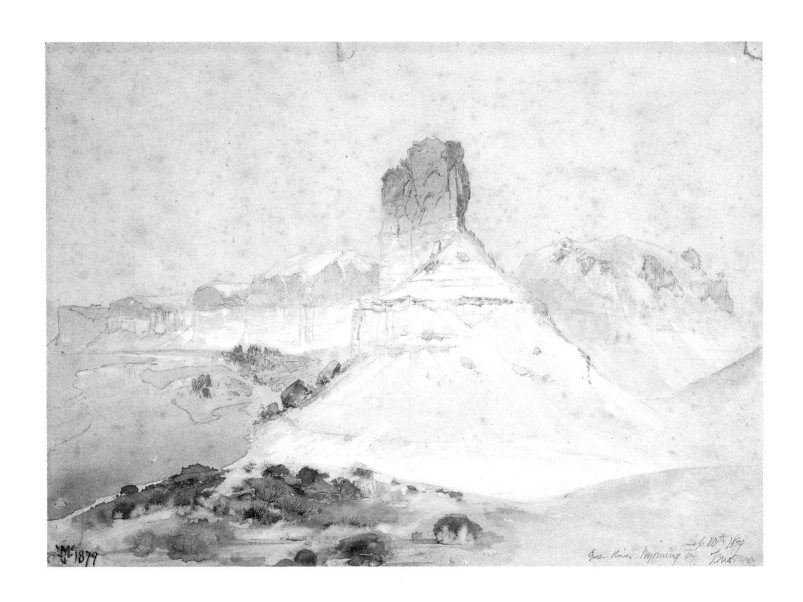

33. Thomas Moran, *Green River, Wyoming*, 1879. Watercolor, 10 × 14½ inches.
Jefferson National Expansion Memorial, National Park Service, St. Louis, Mo.

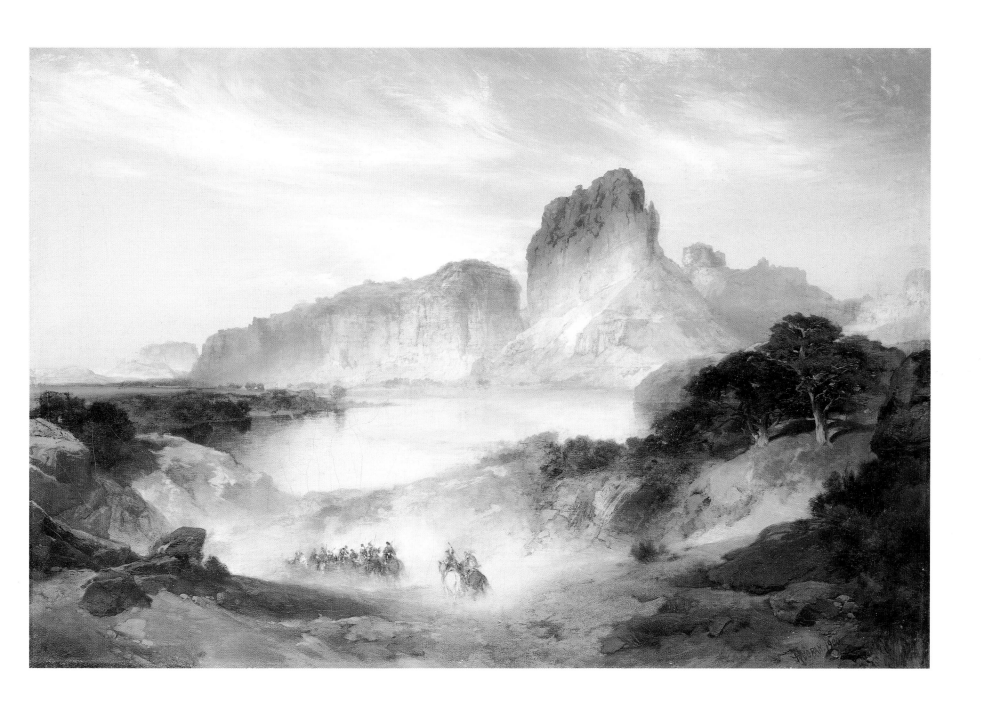

34. Thomas Moran, *The Cliffs of Green River, Wyoming*, 1900. Oil on canvas, 20¼ × 30¼ inches.
U.S. Department of State, Diplomatic Reception Rooms, Washington, D.C.

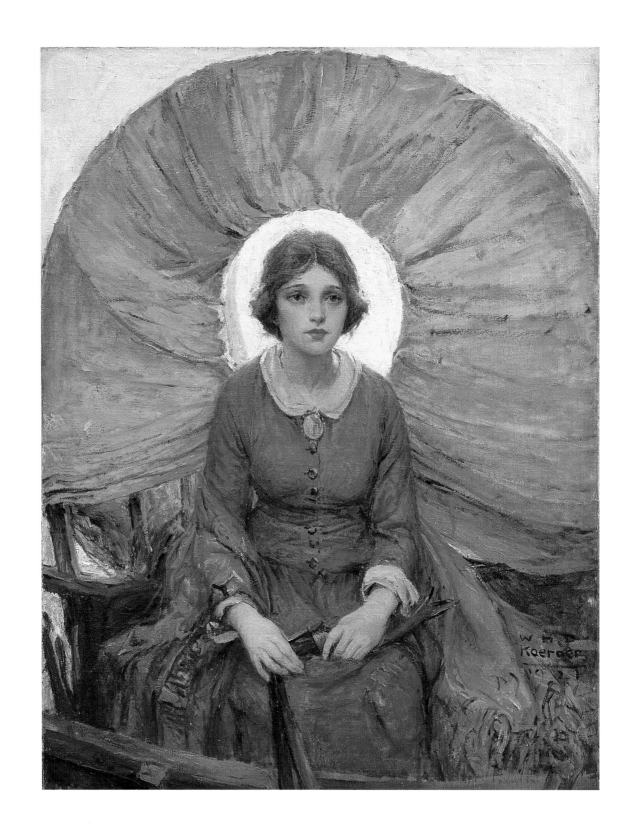

FRESH INSIGHTS

New perspectives and methodologies continually challenge traditional scholarship regarding some of the most commonly recognized images in western American art. Fresh social, political, and psychological insights into this canon have led to significant reevaluations of the popular myths about the settling of the West and the artists who created this body of work. Feminist art historians, for example, have reconsidered the way women have been depicted in the art of the West.

The masculine figure, cast as explorer, hunter, and conqueror, is pervasive in art of the American West. In fact, according to Corlann Gee Bush, images of men outnumber those of women ten to one.[2] This is confirmed by Susan Prendergast Schoelwer, who has studied the curious absence of Native American and European American women in art of the West.[3]

Moreover, when women are portrayed, they rarely assume an active role. They generally appear as helpless, involuntary participants in dramas that are beyond their control or simply as icons of maternity, not as individuals. This stereotype prevails despite the records documenting that a great number of women not only went west but also were willing, active participants in a broad range of activities on the frontier.

William H. D. Koerner's *Madonna of the Prairie* (figure 35) is a typical portrayal of women in western art. Molly Wingate, the heroine of Emerson Hough's novel *The Covered Wagon* (1922), is framed in the halo of a Conestoga wagon. Rather than a conqueror of the prairie or even an individual in charge of her own destiny, she is merely a symbol of purity and passivity. The loosely held reins, the distant look in her eyes, and the

35. William H. D. Koerner, *The Madonna of the Prairie,* 1921. Oil on canvas, 37 × 28¾ inches. Buffalo Bill Historical Center, Cody, Wyo.

shawl that has slipped off to reveal her slumped shoulders suggest that she is vulnerable to whatever threat lies in wait. Nothing in Koerner's painting suggests that Molly is connected to her environment. She is completely surrounded by the canvas opening. Within this confined, seemingly exalted space, she is isolated from the land and its inhabitants.

Such passive, sheltered women have little in common with the seemingly fearless cowboys in Erwin E. Smith's *A Pitching Bronc* (figure 36) and Frederic Remington's *The Broncho Buster*

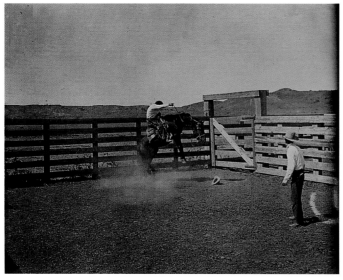

36

(figure 37) or the epic characters in Charles M. Russell's *Romance Makers* (figure 3). The psyche of these men could not be more different from that of the Madonna's. These men epitomize strength, cunning, and bravery. Rather than staring blankly, their eyes scan the distance or focus with determination on the task at hand. Certainly, the unerring and confident demeanor of Smith's and Remington's riders belies their perilous situations.

The riders in Russell's *Romance Makers* are given a dynamic and significant role, symbolizing the heroic nature of cowboys, mountain men, and explorers of the early 1880s—the mythical symbols of the fast-disappearing West.[4] Although just as legendary as the Madonna figure, these men appear to exist in a specific time and place. The riders are obviously at the end of a long journey—it is sunset, and miles of rugged terrain loom behind them—yet they ride high in their saddles. Compositionally, they are connected to and a part of the landscape around them: their clothes reflect the colors of their scenic surroundings, and their human forms echo and overlap with shapes in the landscape, suggesting not only that they are at ease in this strange place but also that they belong there.

Stephanie Foster Rahill

36. Erwin E. Smith, *A Pitching Bronc*, 1907. Contact print photograph, 4 × 5 inches. Nita Stewart Haley Memorial Library, Midland, Tex.

37. Frederic Remington, *The Broncho Buster*, 1895. Bronze, 23⅝ × 20½ × 7 inches. Desert Caballeros Western Museum, Wickenburg, Ariz.

38. Charles M. Russell, *A Bronc Twister*, 1920. Bronze, 18 × 12½ × 8¼ inches. Montana Historical Society, Helena, Mont. Gift of Eugene E. Wilson in memory of Eugene Talmadge Wilson.

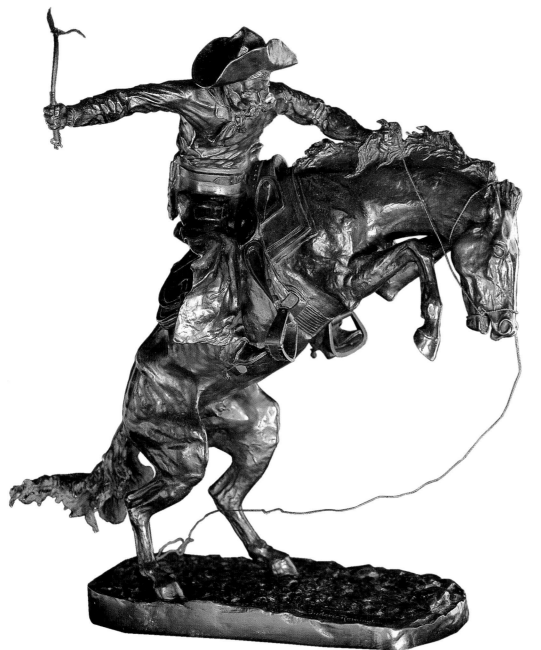

37

38

While admitting that Albert Bierstadt's landscapes were more beautiful than even the Creator's, Mark Twain lamented the fact that the artist strayed from factual documentation of the sights that he had sketched and photographed during his 1863 visit to California's Yosemite Valley. Painters like Bierstadt who traveled west, either with survey groups or on their own, were expected to record anthropological, historical, and geological data, but how much of that factual information ended up on their canvases depended entirely on the artist.

Many American artists of the late 1800s were trained to paint landscapes in nineteenth-century German romantic traditions, which placed a higher value on capturing mood than on rendering truth. Although Bierstadt relied greatly on his field sketches, he created his epic landscapes back East in his New York studio, where his personal vision dominated the realities he had encountered in the West. Twain criticized Bierstadt's landscapes as formulaic inventions, composites of actual landforms, and decried the idea of an American artist veiling the great American scene in the theatrical trappings of a European-inspired style. "We do not want this glorified atmosphere smuggled into a portrait of Yosemite, where it surely does not belong," he admonished.[5]

Despite Twain's objections, Bierstadt had many supporters. In fact, in the 1860s he was considered the preeminent painter of western landscapes. The exhibition and record sales of several panoramic canvases produced after his initial western trips had earned him early fame. Grand landscapes like *Wind River Mountains, Nebraska Territory* (figure 41), painted after his first trip west in 1859, instilled in eastern American audiences a sense of national pride. The inclusion of enough descriptive detail to lend authenticity led viewers to believe that the artist had personally experienced the imposing landscapes he had painted and that they could live vicariously through these images. It did not matter to them that Bierstadt, as Twain and a growing number of others had recognized, was not completely factual in his transcriptions of nature. According

39. Frederic Remington, *Marching in the Desert*, 1888. Oil on canvas, 18 × 28 inches. American Heritage Center, University of Wyoming, Laramie, Wyo.

to Nancy K. Anderson, the American public put such a high value on the West as a source of national pride that it was "inclined (even eager) to accept as accurate Bierstadt's spectacular western landscapes."[6]

In 1863 Bierstadt undertook his second overland trip west, this time to California and Oregon, along with the writer and journalist Fritz Hugh Ludlow. This trip inspired him to return to the West Coast a number of times during the next two decades. *El Capitan, Yosemite Valley, California* (figure 19), painted in the 1870s, is typical of Bierstadt's large, commanding landscapes that relied on the romantic conventions he had studied in Düsseldorf. The artist has created a deep, vast space faceted by planes of storm-darkened skies and striking, sun-lit landforms. A dreamlike haze casts a supernatural light on the entire scene and heightens the drama. Meanwhile, in the foreground a cozy, bucolic scene of travel-weary explorers setting up camp completes a view that seems as accessible as it is awe inspiring.

Such scenes were extremely popular and had a wide audience, in large part because of Bierstadt's adeptness in promoting—some would say exploiting—his works. He exhibited his popular large-scale panoramic landscapes widely, and his audience increased even further through the production of lithographs and engravings based on his best-known work.[7] Unfortunately, Bierstadt's skills as a painter and self-promoter were not enough to sustain his popularity, and by the end of his life, he was virtually forgotten. The passing of time, however, has erased old prejudices and increased appreciation of Bierstadt's artistic contributions. Today he is considered among America's foremost landscape painters. *Stephanie Foster Rahill*

40. Albert Bierstadt, sketchbook from the artist's trip west (pages 113–14), 1864. Pen on paper, 3½ × 5½ inches. Mabee-Gerrer Museum of Art, Shawnee, Okla.

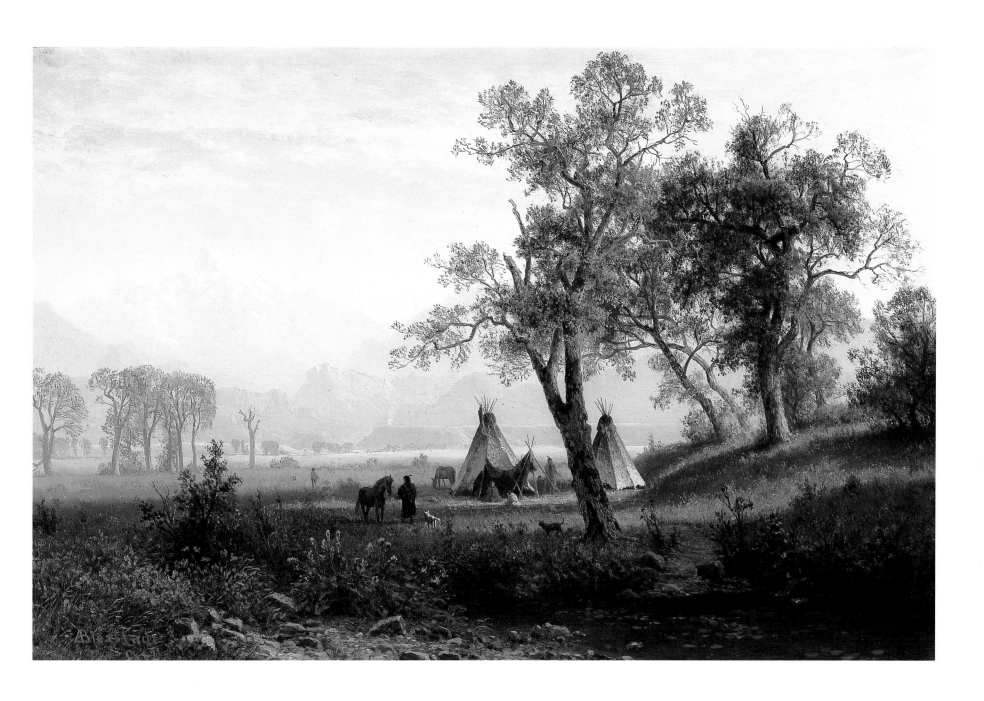

41. Albert Bierstadt, *Wind River Mountains, Nebraska Territory*, 1862. Oil on composition board, 12 × 18½ inches. Milwaukee Art Museum, Milwaukee, Wis. Layton Art Collection.

42. John Mix Stanley, *Butte on the Del Norte*, 1846. Oil on academy board, 9¾ × 12½ inches.
Collection of the Eiteljorg Museum of American Indians and Western Art, Indianapolis, Ind.

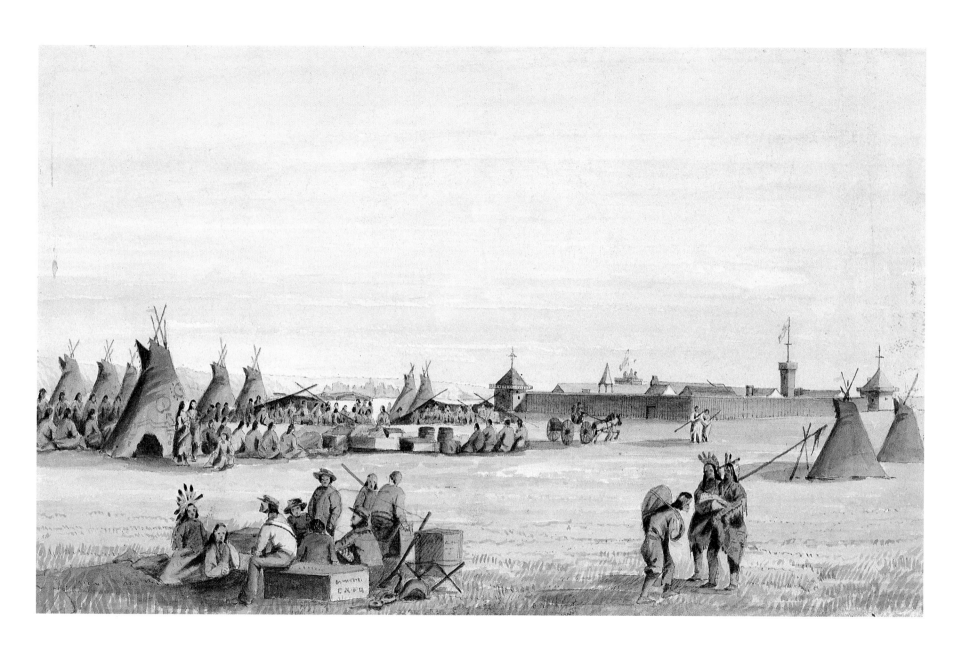

43. John Mix Stanley, *Fort Union and Distribution of Goods to the Assiniboins,* 1853. Pencil and watercolor, 10½ × 15⅞ inches.
Yale University Art Gallery, New Haven, Conn. Paul Mellon Collection.

The belief among citizens of the United States that they had the right to dominate the inhabitants of the North American continent, including its human inhabitants, was widely held between 1840 and 1870. This nineteenth-century version of the principle of Manifest Destiny coincided with a surge in westward migration, made possible by technological advances in transportation and communication. Railway companies and land promoters commissioned many artists of the day to create visual equivalents of the idea of American progress.

The progress theme was portrayed so frequently that a rather consistent iconography evolved. *American Progress* (figure 44), John Gast's only known work, is one of the most illustrative of this symbolism. The composition resulted from a specific commission Gast received from George A. Crofutt, the publisher of *Crofutt's Overland Tourist and Pacific Coast Guide,* an annual tour guide. In his instructions for what became the frontispiece for the 1878–79 issue, Crofutt outlined each element in great detail. Trains, telegraph poles, and clusters of established cities were to provide proof of civilization and technological mastery. A

female form, Lady Progress, would hover across the landscape, spreading knowledge, morality, and prosperity in her wake and giving chase to darkness, wild animals, and the last vestiges of native peoples. Crofutt's instructions for this allegorical figure provide an amusing yet instructive impression of this era's idea of national progress. He envisioned

[a] beautiful and charming female . . . floating westward through the air bearing on her forehead the "Star of Empire." She has left the cities of the East far behind, crossed the Alleghenies and the "Father of Waters," and still her course is westward. In her right hand she carries a book—common school—the emblem of education and the testimonial of our national enlightenment, while with the left hand she unfolds and stretches the slender wires of the telegraph, that are to flash intelligence throughout the land.[8]

Lady Progress's book of knowledge and escort of tight, orderly rows of wagon trains showed Crofutt's and Gast's contemporaries that westward expansion was being carried out in a rational, systematic manner and as such was legitimate. While paintings such as *American Progress* and Fanny F. Palmer's

44. John Gast, *American Progress,* 1873. Chromolithograph by George A. Crofutt, 12 × 16 inches. Library of Congress, Washington, D.C.

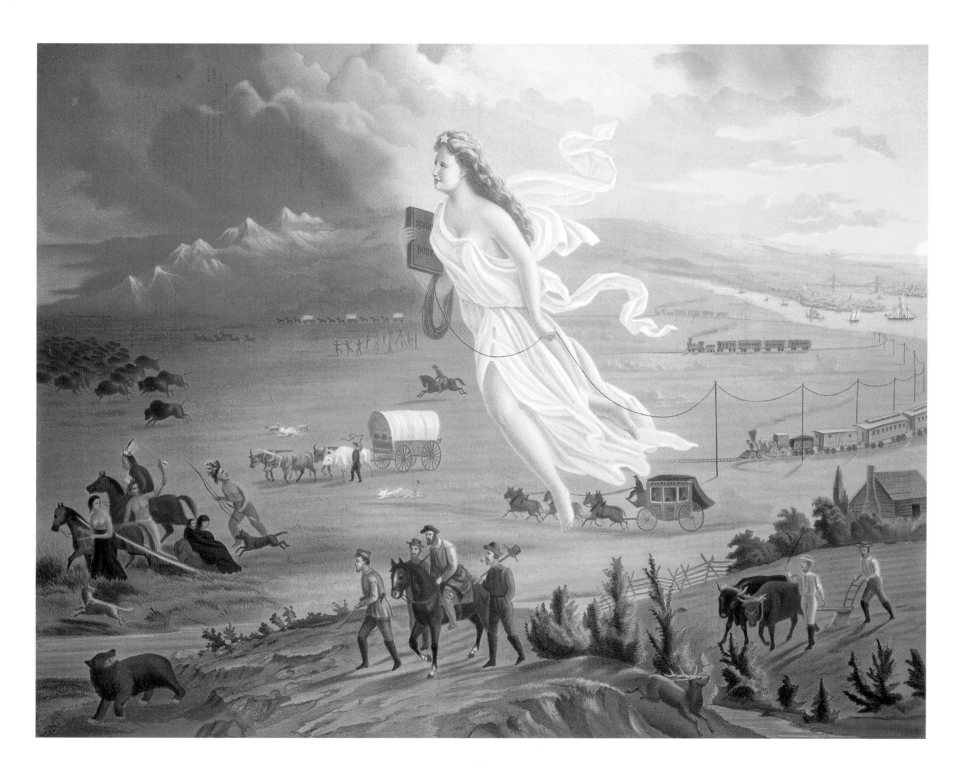

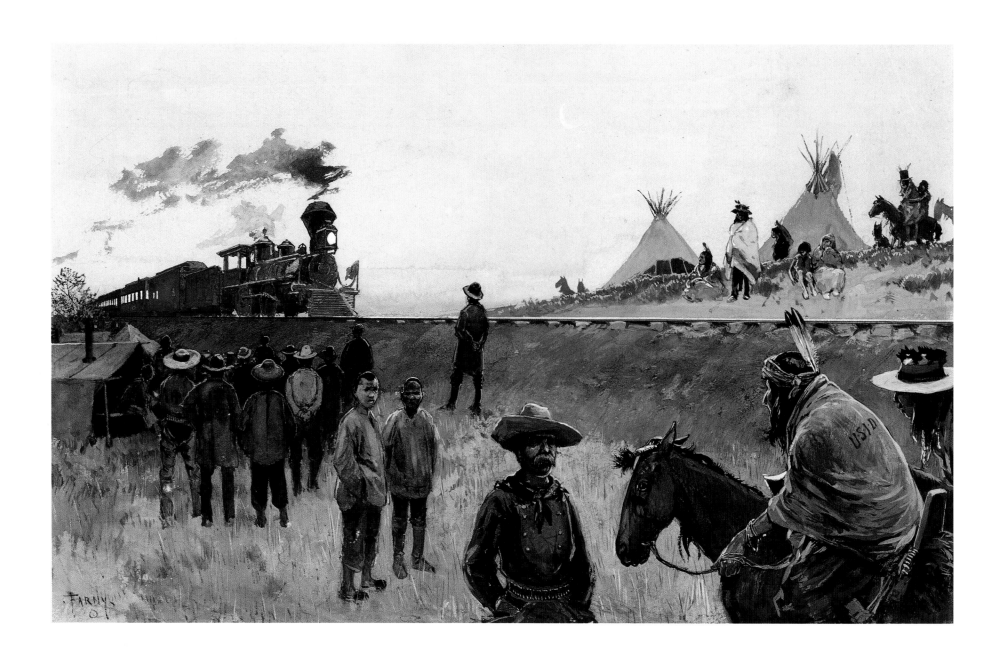

Across the Continent. Westward the Course of Empire Takes Its Way (figure 50) allude to the passing of the frontier or the disrupted lives of its previous inhabitants, their overall expressions are unabashedly positive. Their mood contrasts with the more solemn tone of Irving R. Bacon's *Conquest of the Prairie* (figure 49) and Henry Farny's *Crossing the Continent—The First Train* (figure 45). According to Brian Dippie's classification of progress paintings, those that emphasize the idea of Indians as a vanishing race, like Bacon's and Farny's paintings, would be called "commemorative," as opposed to the "celebratory" images of Gast and Palmer that eulogize Indian displacement in the name of progress.[9]

Although Bacon's and Farny's paintings present an almost identical narrative, Bacon's provides the strongest counterpoint to Gast's celebratory scene. In *Conquest of the Prairie,* a group of Indians commands the center and foreground of the painting. Unlike the Indians in Gast's depiction, who are being driven from their homes, these remain stationary, as if frozen in time, witnesses to the pioneer caravan that passes just in front of their encampment. The dark colors of Bacon's painting and its more atmospheric quality lend a somber, nostalgic feel quite unlike the bright colors and nearly caricature-like figures found in the celebratory paintings. The composition of *Conquest of the Prairie* seems to suggest that although the Indians, bastioned by the dark cloud of buffalo at their feet, have the potential to impede progress, they have chosen instead to step aside. They sit stoically, slumped in their saddles, as they quietly observe a confident rider, William ("Buffalo Bill") Cody, leading the parade of dust-stirring wagons. Bacon did not give his Indians faces, which would have defined them as individuals. Instead, they serve as symbols of the passing of the Indian lifeways, swept away by progress. *Stephanie Foster Rahill*

45. Henry Farny, *Crossing the Continent—The First Train*, 1883. Gouache on paperboard, 9¼ × 15¼ inches. U.S. Department of State, Diplomatic Reception Rooms, Washington, D.C. Gift of Mr. and Mrs. John A. Hill.

46. E. Hall Martin, *Mountain Jack and a Wandering Miner,* 1850. Oil on canvas, 39½ × 72 inches.
Oakland Museum of California, Oakland, Calif. Gift of Concours d'Antiques, Art Guild.

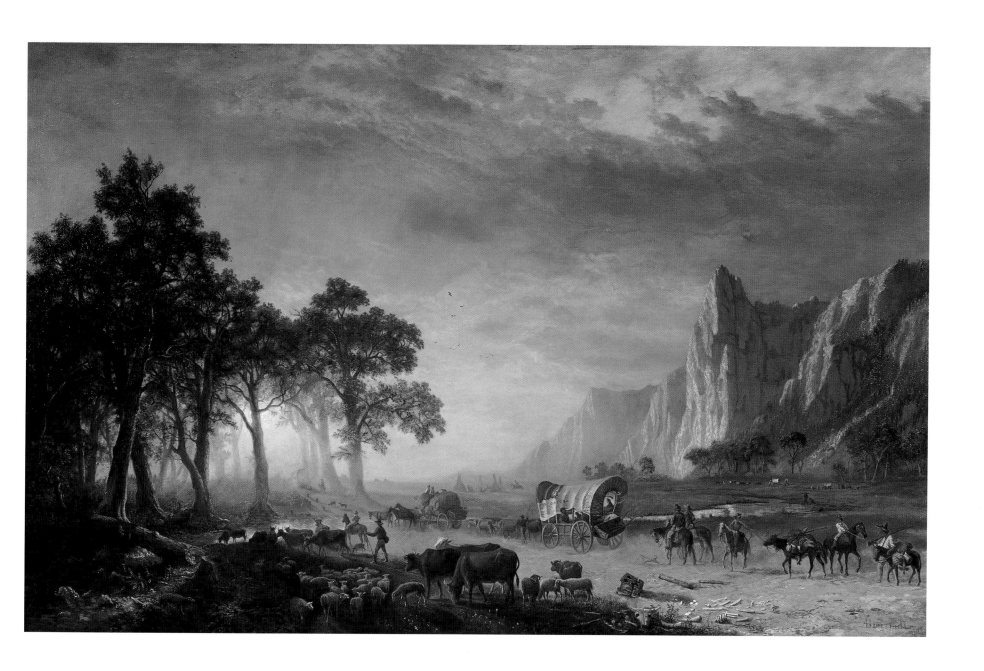

47. Albert Bierstadt, *Oregon Trail*, 1869. Oil on canvas, 31 × 49 inches.
Collection of The Butler Institute of American Art, Youngstown, Ohio. Gift of Joseph G. Butler III, 1946.

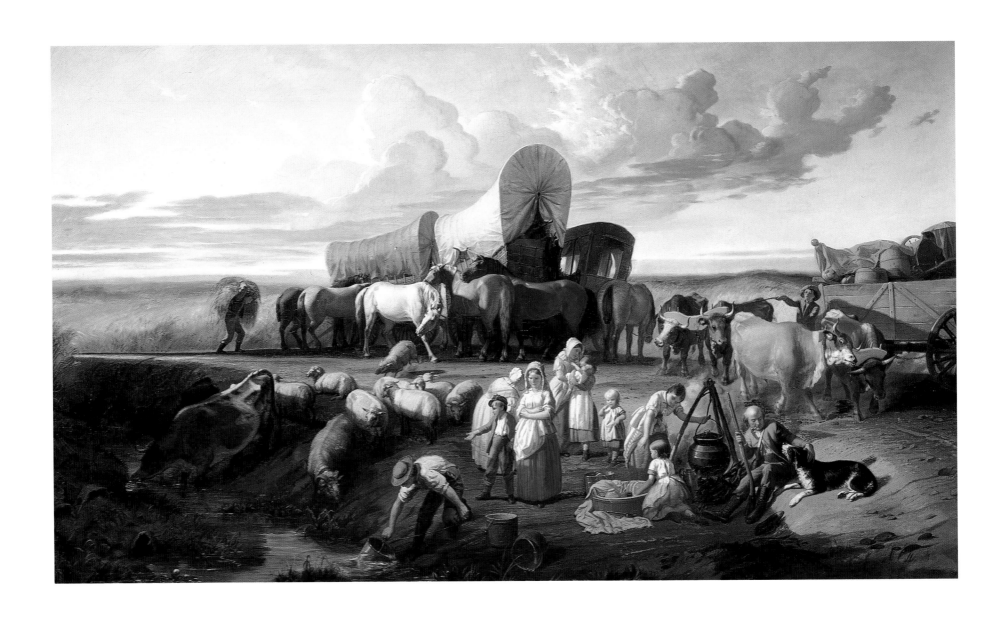

48. Benjamin Franklin Reinhart, *The Emigrant Train Bedding Down for the Night*, 1867. Oil on canvas, 40 × 70 inches. The Corcoran Gallery of Art, Washington, D.C. Gift of Mr. and Mrs. Lansdell K. Christie.

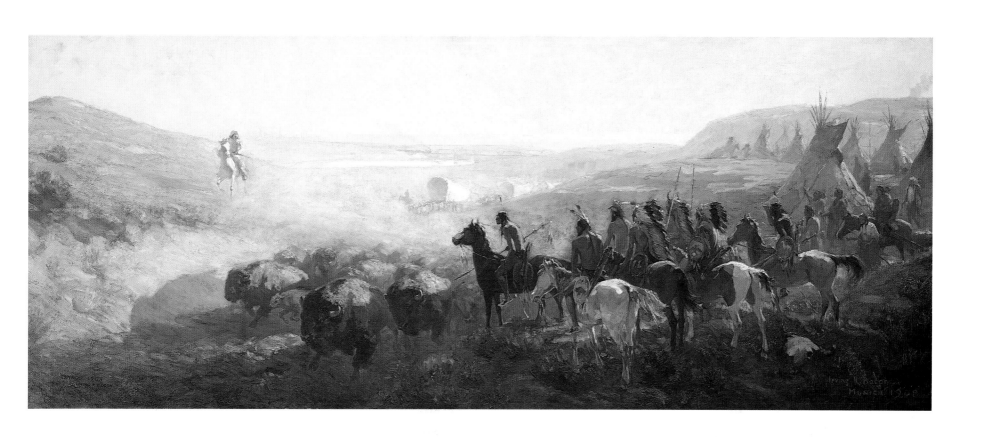

49. Irving R. Bacon, *Conquest of the Prairie*, 1908. Oil on canvas, 47¼ × 118½ inches.
Buffalo Bill Historical Center, Cody, Wyo. Bequest in memory of Houx and Newell families.

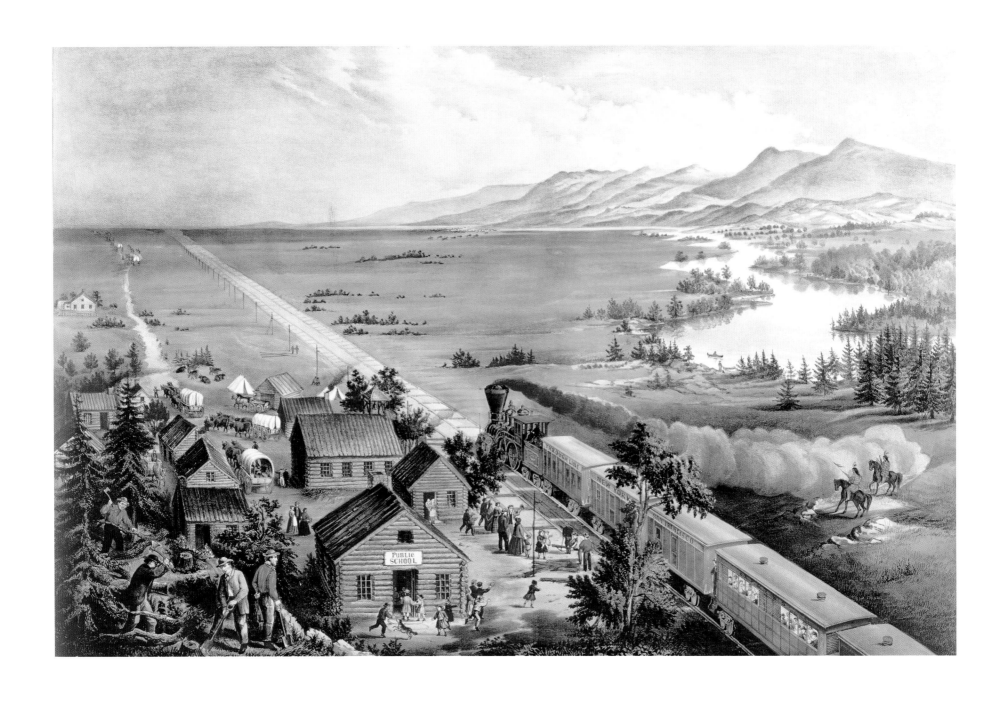

50. Fanny F. Palmer, *Across the Continent. Westward the Course of Empire Takes Its Way*, 1868. Colored lithograph published by Currier and Ives, 21 × 28 inches. U.S. Department of State, Diplomatic Reception Rooms, Washington, D.C. Elizabeth Hay Bechtel.

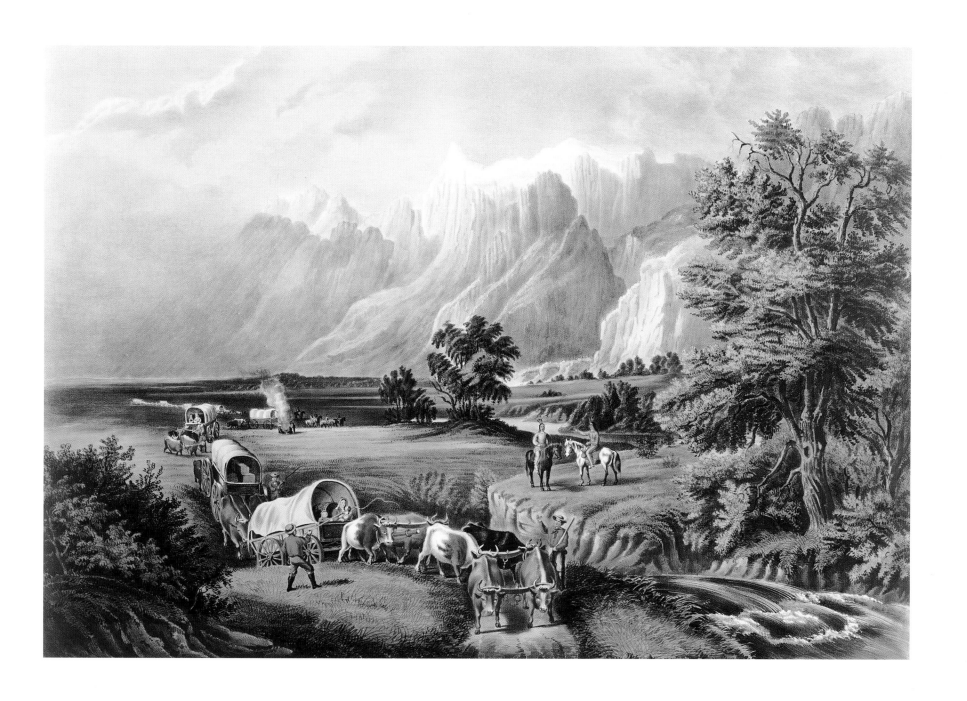

51. Fanny F. Palmer, *The Rocky Mountains. Emigrants Crossing the Plains*, 1866. Colored lithograph published by Currier and Ives, 21 × 27 inches. U.S. Department of State, Diplomatic Reception Rooms, Washington, D.C. Elizabeth Hay Bechtel.

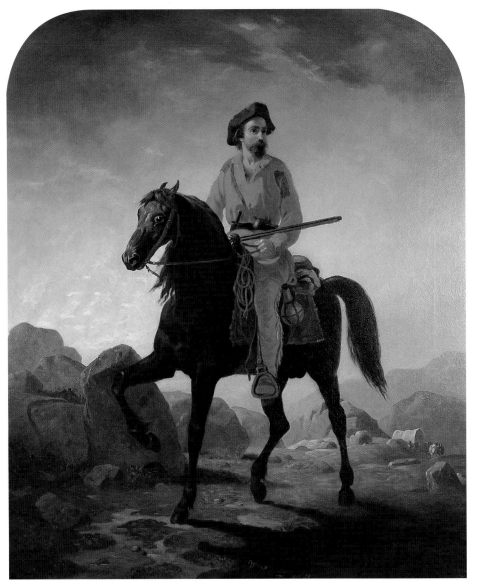

52

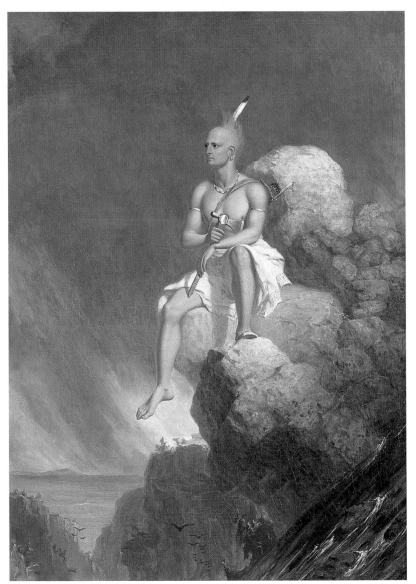

53

After nearly a century of spasmodic conflict, European Americans recast Native Americans in a nostalgic, sentimental light once their overt threat was perceived as nonexistent. The "noble savage" emerged as a dominant theme in western art, as did the "heroic civilizer"—the explorers and trailblazers, western supermen who epitomized the new America.

The image of the Indian in American vernacular culture has undergone a series of changes as a result of circumstances, social climate, and prevailing attitudes. Early encounters with Native Americans gave rise to perceptions of them as savages incapable of becoming "civilized" by European standards. Routinely portrayed as intransigent and warlike, the indigenous people of the New World were conveniently seen as the antithesis of civilized society as long as their presence precluded expansion into new territories. Once the threat of resistance by Native Americans was minimal, it was safe for European Americans to eulogize, idealize, and memorialize the positive qualities of the "natural man."

The visual arts gave substance to the idea of the noble savage as an active player in the European American settlement of the West. Subjected to Renaissance conventions of portrayal, the Indian was depicted in classical and neoclassical poses that enhanced this romantic notion of the noble savage. Charles Deas's oil painting *A Solitary Indian, Seated on the Edge of a Bold Precipice* (figure 53) and a bronze by Alexander Phimester Proctor entitled *The Indian Warrior* (figure 57) exemplify this concept. The warrior in Deas's painting strikes a dignified pose befitting a Roman orator as he stares contemplatively past the viewer; the precipice on which he is seated creates a downward diagonal thrust that focuses attention on the beckoning Eden in the background. Proctor's bronze of a bonneted warrior astride his spirited mount, reminiscent of the Parthenon's equestrian friezes, evokes a sense of nobility and inherent dignity. In both works the affinities with classical themes and, by association, the ennobling virtues of the ancients come to the fore.

Precipitating the Indian's demise were the trailblazers, the "heroic civilizers," who opened the way for the march of progress, with all its ramifications, into the vast reaches of the West. Exemplified in William Ranney's *Kit Carson* (figure 52), the heroic frontiersman was a harbinger of civilization's inevitable displacement of the wild, uncultivated tracts west of the Mississippi. The figure of Carson, gun slung across his saddle, dominates the composition in the same manner that civilization would dominate the West. The entire scene is set against a vibrant glow, the light of civilization illuminating the new land and pushing the dark shadows outward.

Bradley A. Finson

52. William Ranney, *Kit Carson*, 1854. Oil on canvas, 30½ × 26 inches. Mrs. J. Maxwell Moran.

53. Charles Deas, *A Solitary Indian, Seated on the Edge of a Bold Precipice*, 1847. Oil on canvas, 36¼ × 26 inches. Autry Museum of Western Heritage, Los Angeles, Calif.

54

54. William Holbrook Beard, *Lo, The Poor Indian,* 1876. Oil on canvas, 20 × 30 inches. Utah Museum of Fine Arts, University of Utah, Salt Lake City, Utah.

55. Adolph Weinman, *Chief Black Bird, Ogalalla Sioux,* 1903. Bronze, 16⅜ × 16½ × 12 inches. From the Collection of Gilcrease Museum, Tulsa, Okla.

56. John Quincy Adams Ward, *The Indian Hunter,* 1860. Bronze, 16 × 14 × 10 inches. Collection of The New-York Historical Society, New York, N.Y. Gift of Mr. George A. Zabriskie.

57. Alexander Phimister Proctor, *The Indian Warrior,* 1898. Bronze, 38⅝ × 38½ × 10½ inches. Mr. and Mrs. W. D. Weiss.

55

56

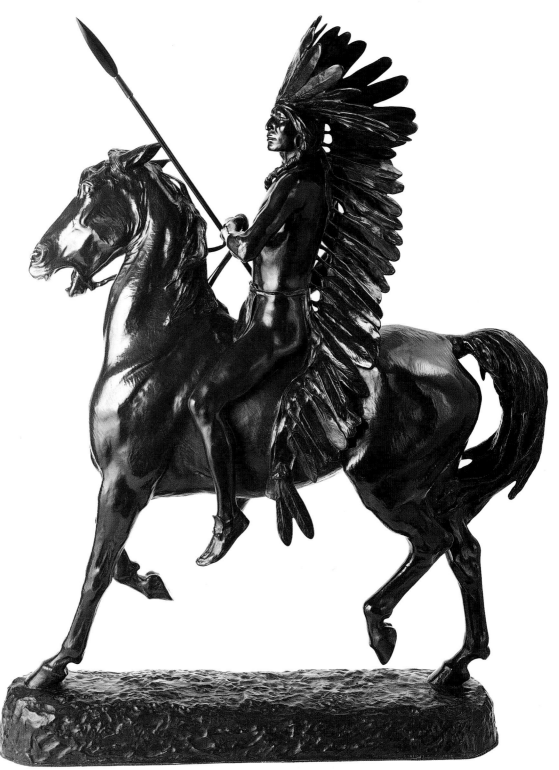

57

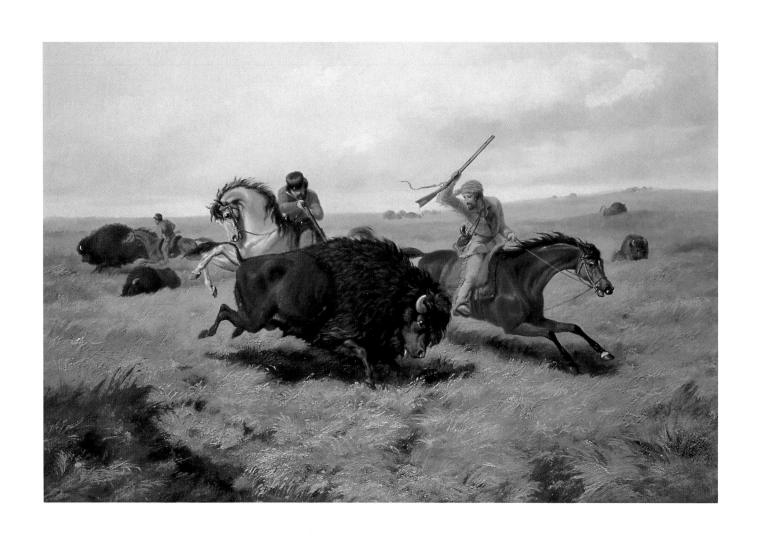

58. Arthur Fitzwilliam Tait, *Buffalo Hunt,* 1861. Oil on canvas, 24½ × 36½ inches.
Mr. and Mrs. W. D. Weiss.

59. Carl Wimar, *Indians Approaching Fort Union*, 1859. Oil on canvas, 24⅛ × 48½ inches.
Washington University Gallery of Art, St. Louis, Mo. Gift of Dr. William Van Zandt, 1886.

VIOLENCE AND MASCULINITY

The mythologized West of popular imagination, peopled by such rugged, solitary hero-figures as the mountain man and the cowboy, has left an indelible mark on the American consciousness. These larger-than-life actors provided easterners with a vicarious outlet to counter the comfortable domesticity of their lives. They also suggested the attendant lawlessness and inherent violence of the West.

The trans-Mississippi West, the lands beyond the Mississippi River, provided a formidable landscape in the minds of most nineteenth-century Americans. It was a region so expansive that it nearly defied the imagination. Imagination, in fact, played a major role in the presentation of this vast area, as well as in the creation of the mythos surrounding its subjugation by "civilized" people. A strong, and therefore masculine, hand was perceived as necessary to civilize the West, and violence was an accepted requisite for subduing the land, its indigenous peoples, and the unrelenting extremes of climate. Robert G. Athearn writes in *The Mythic West:*

The pioneers who made their way west by wagon train invariably wrote about the exaggerations of this land. To them the trees were the tallest, the winds the strongest, the rains the heaviest, the thunder the loudest, the grasshoppers the biggest, the temperature changes the greatest. The land certainly encourages boasts like these.[12]

Indeed, such a land was greatly inviting to the Americans who constituted the ranks of the western trappers, settlers, immigrants, and cattlemen. Alfred Jacob Miller's *Trappers Saluting the Rocky Mountains* (figure 61) presents a panorama so vast that it threatens to swallow the men in its enfolding vista. The two mountain men in the center foreground stand

60. N. C. Wyeth, *Gunfight,* 1916. Oil on canvas, 34 × 25 inches. The Harmsen Museum of Art, Denver, Colo. William and Dorothy Harmsen Collection.

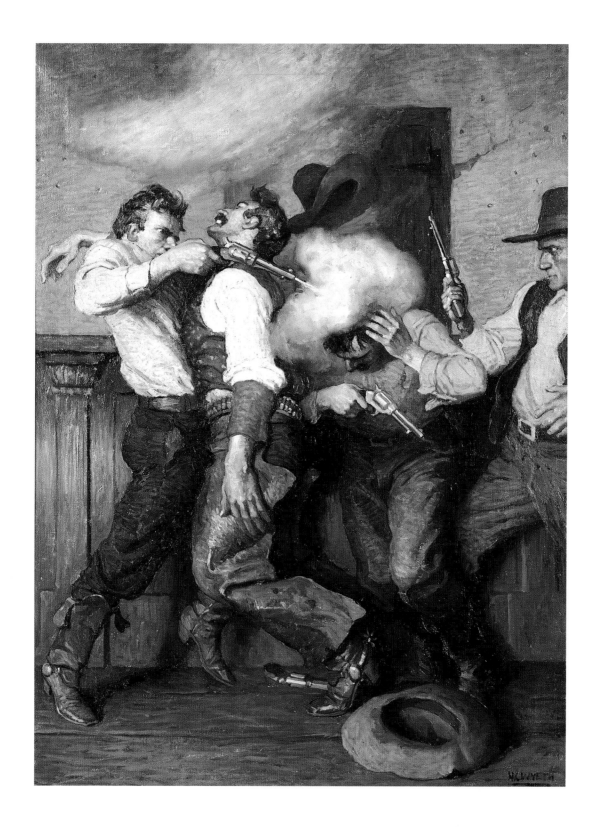

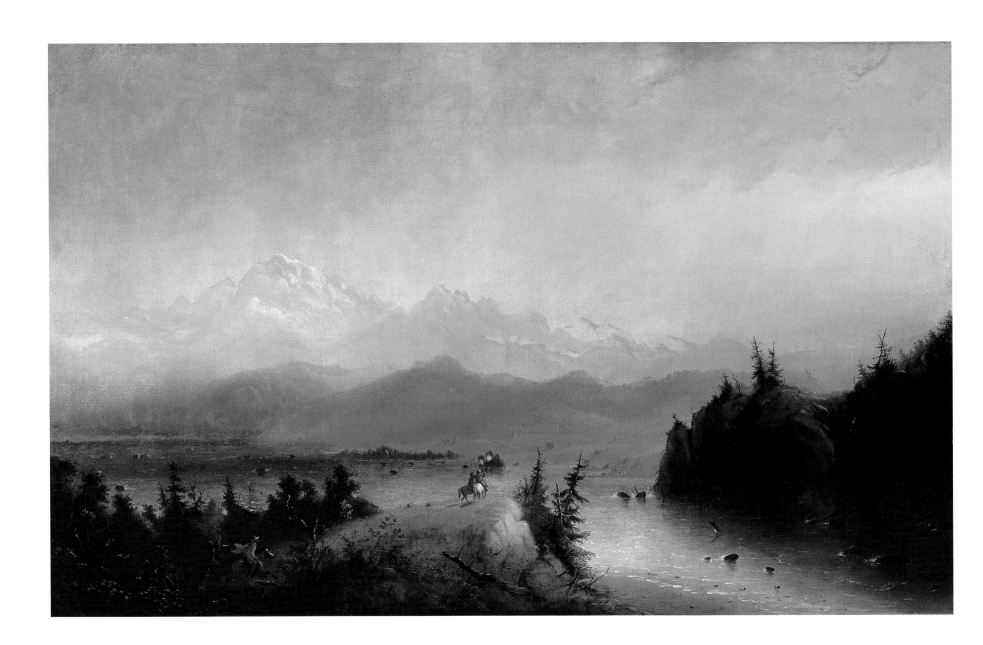

on the phallic butte overlooking a lake, poised to initiate the feats of masculine derring-do required to breach the monolithic barrier of nature itself, opening the way for those who are to follow.

Continuing the themes of man's attempt to overcome the seemingly unending natural obstacles to westward expansion and the use of violence as a means to an end is an 1871 woodcut from *Leslie's Illustrated News* (figure 5). It depicts the wanton slaughter of a buffalo herd, seen as impeding civilization's inexorable march to the Pacific Ocean. The symbol of destruction is that instrument of European American technology, the train. Buffalo in front of the smoke-belching behemoth scatter in panicked disarray, their fate amply prophesied by those shot from the train and fallen in its wake.

The perception of the West as untamed virgin wilderness fraught with dangers and obstacles evoked in the American mind the need to forcibly tame the region and its peoples and wildlife. This perception is embodied in works such as Frederic Remington's *Broncho Buster* (figure 37), a depiction of violent

energy threatening to break free. Riding the tornadic bronco, a metaphor of nature unbridled, is the cowboy, adeptly countering the animal's violent efforts to dislodge him. In sharp contrast to this explosive energy, the rider conveys a calm conviction that he will eventually tame the unruly beast.

The American conception of the West involved civilized European Americans in direct confrontation both with nature and its various elements and with their own latent lawlessness in a land crying out for the stabilizing hand of civilization. N. C. Wyeth's 1916 canvas entitled *Gunfight* (figure 60) depicts this collision between the lawful and the lawless. Western bravado is epitomized by the lone individual who displays incredible courage in the face of overwhelming odds and comes out on top. The clean-shaven hero, a figure immortalized in media from pencil to film, is portrayed as facing down not one but three adversaries. The overwhelming odds justify the use of unrestrained violent action at this moment and, by implication, in the whole process of making the West a safe place.

Bradley A. Finson

61. Alfred Jacob Miller, *Trappers Saluting the Rocky Mountains*, n.d. Oil on canvas, 25 × 38⅞ inches. Buffalo Bill Historical Center, Cody, Wyo.

The first artist-naturalists to make visual records of the trans-Mississippi West in the early decades of the nineteenth century followed a documentary artistic tradition that had begun in the eighteenth century, the age of global exploration. Eager audiences, hungry for a vicarious taste of the West, relied on the accuracy of artists' depictions to provide them with information about the new territory. Historically, the artwork that resulted from expeditionary trips has been appreciated more for its scientific and historical value than for formalistic or aesthetic concerns. In the late twentieth century, however, the individual creative genius of these early naturalist artists has been acknowledged. Moreover, it is known that many of these naturalists were competent and skilled draftsmen as well as rugged adventurers who thrived during their dangerous treks through inhospitable climate and terrain.

Titian Ramsay Peale—the youngest son of the artist and naturalist Charles Willson Peale, founder of the Philadelphia Museum, the first museum of natural history in the United States—was only nineteen years old when he was secured by Stephen H. Long to accompany one of the first government-sponsored scientific explorations of the trans-Mississippi West in 1819. On this trip to the Rocky Mountains, the young artist was to serve as assistant naturalist, gathering previously unrecorded plants, animals, insects, and geologic specimens, while his associate, Samuel Seymour, was to paint portraits of Indians and landscapes (as it turned out, Peale painted Indians as well). Peale had grown up working in his father's museum, where he and his brothers were steeped in the philosophy of the Enlightenment, with its emphasis on individualism and an ordered universe. Long's expedition, therefore, provided the energetic, bright young man with an opportunity to participate in the scientific classification of what was considered a new world, the western frontier. In sketches and watercolors from this journey, Peale recorded some of the earliest known portrayals by an Anglo-American artist of Plains Indian warriors and buffalo hunters, such as *Indian Brave on Horseback* (figure 66), as well as the first glimpses easterners had seen of such Great Plains wildlife as antelope, prairie chickens, and grasshoppers.

Peale's *Antelope (head)* (figure 67) served as a field sketch for his painting *American Antelope*, in which he positioned a pronghorn family in the foreground against a distant view of distinctively western landforms. With this formulaic compositional strategy, the artist was able to include the greatest amount of descriptive detail about the animal and its habitat, including the desertlike terrain with its indigenous prickly cacti and oddly delicate wildflowers. Kenneth Haltman and Barbara Novak suggest another reason for Peale's purposeful

62. Carl Rungius, *Alert,* 1905. Bronze, 16¾ × 19¼ × 9½ inches. Rockwell Museum, Corning, N.Y. Collection of Robert F. Rockwell Jr.

placement of the animals in the foreground. By creating a barrier of the antelope and allowing viewers just a glimpse of the landscape beyond, the artist subordinated their view to his own. In other words, he has heroically braved the dangers of the wilderness to bring audiences these extraordinary scenes, which they can experience only through him.[10] Samuel Seymour's *View of the Rocky Mountains on the Platte 50 Miles from Their Base* (figure 68), with its plantings and grazing bison, illustrates an approach similar to Peale's landscapes.

Like Peale, the German artist Karl Bodmer was also quite young when he was hired to join Prince Maximilian of Wied-Neuwied on his 1832–34 scientific expedition of North America, traveling from Boston to Fort McKenzie, near what is now Great Falls, Montana. A rugged individual able to withstand the physically and psychologically difficult two-year excursion, Bodmer was also an observant naturalist. As much as Peale had been informed by the ideology of the Enlightenment, Bodmer was immersed in Germany's scientific climate, and his art is acclaimed for its exceptionally adept depictions of Indians and wildlife. *Cree Woman* (figure 65) shows his sensitivity and skill in portraying the sitter's physical and psychological characteristics. His watercolor *Head of an Antelope* (figure 64) is a precise rendering of the texture of the animal's fur and its characteristic two-tone coloring. Although the image is believed to derive from a hunt trophy rather than a living animal,

Bodmer was able to capture its majesty and dignity with a spirit not commonly seen in scientific studies.

The years of Maximilian's expedition were pivotal in American history. In 1832 the massive overland migration had not yet begun, but by 1834 it was in full swing.[11] By the time the animal painter William Jacob Hays made his own personal journey up the Missouri River in 1860, the western frontiers, made more accessible by steamboat travel, were receding. Instead of providing eastern audiences with their first glimpses of the West, as Peale and Bodmer had, Hays painted a West that was quickly disappearing. A vigilant amateur naturalist who kept accurate and detailed notes on flora and fauna, Hays took a particular interest in buffalo and is known primarily for his paintings of these great beasts that still roamed the plains but were on the verge of vanishing.

The Stampede (figure 75), in which terror-stricken buffalo charge blindly into a hidden ravine, aptly illustrates the visual and physical force of those latter-day buffalo herds. Hays's lively and descriptive journal entries and letters about such encounters with buffalo reveal not only the artist's fascination with them but also his keen sense of adventure. His buffalo often stare directly or defiantly at the viewer, forcing even those who could see them only secondhand to empathize with the strange creatures and share the artist's excitement.

Stephanie Foster Rahill

63. Lt. Col. William Thorn, *Map to Illustrate the Route of Prince Maximilian,*
an illustration for Prince Maximilian's *Travels in the Interior of North America, 1832–34, 1843.*
Engraving from a twentieth-century Alecto edition of the original plate, 18 × 34½ inches. Joslyn Art Museum, Omaha, Neb.

BRITISH AMERICA

LAKE SUPERIOR

LAKE HURON

LAKE MICHIGAN

LAKE ONTARIO

LAKE ERIE

ATLANTIC OCEAN

OSAGE DISTRICT

PAWNEES

MISSOURI

ILLINOIS

OHIO

GREAT FALLS of the **MISSOURI**
GROSSE FÄLLE des
GRANDES CATARACTES du

Total Falls
357 Feet perpendicular Height in 2⅔ Miles

Explanations. (Erklaerungen.)

Explanations. (Erklaerungen.)

ITASKA Lake or Lac LABICHE
The SOURCE of the MISSISSIPPI

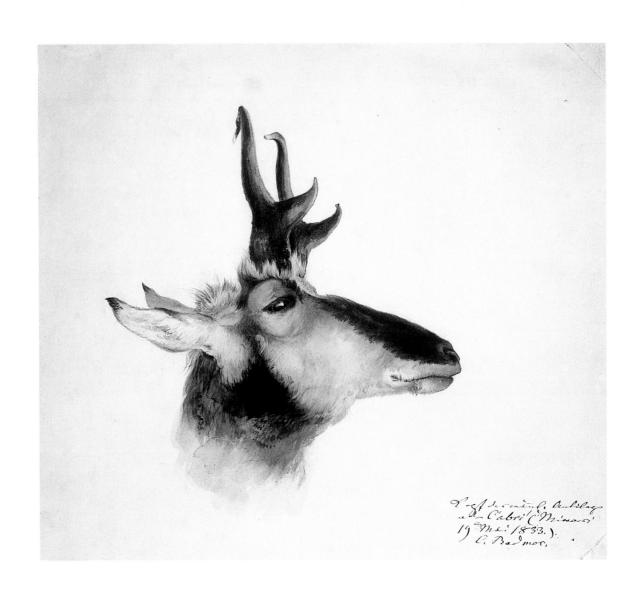

64. Karl Bodmer, *Head of an Antelope*, 1833. Watercolor, 7¾ × 11⅛ inches. Joslyn Art Museum, Omaha, Neb.

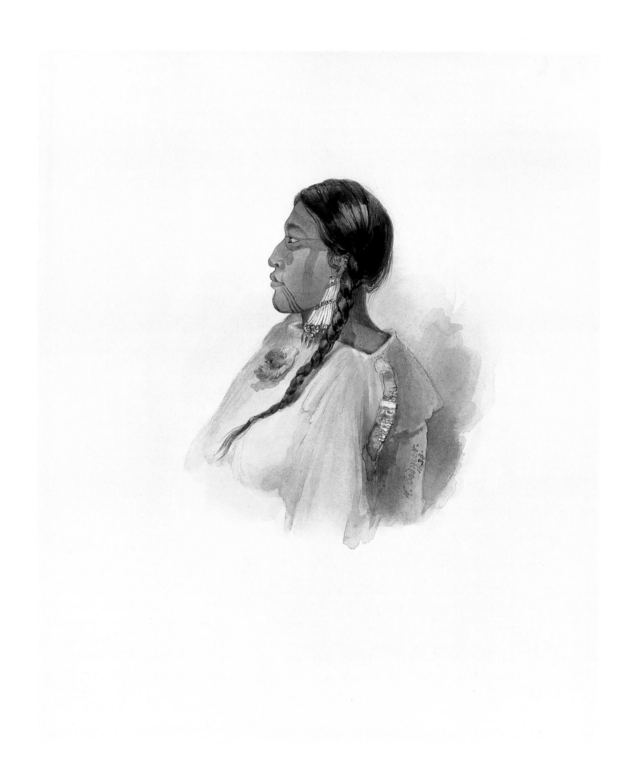

65. Karl Bodmer, *Cree Woman*, 1834. Watercolor and pencil, 10⅜ × 8⅝ inches. Joslyn Art Museum, Omaha, Neb. Gift of Enron Art Foundation.

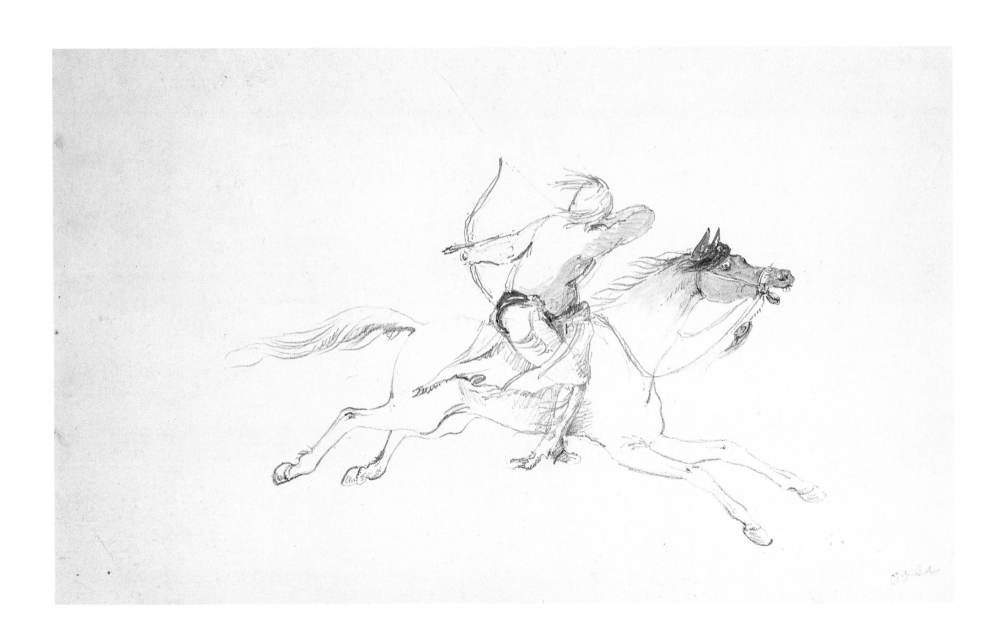

66. Titian Ramsay Peale, *Indian Brave on Horseback*, 1820. Watercolor and pencil, 5½ × 9¼ inches. American Philosophical Society, Philadelphia, Pa.

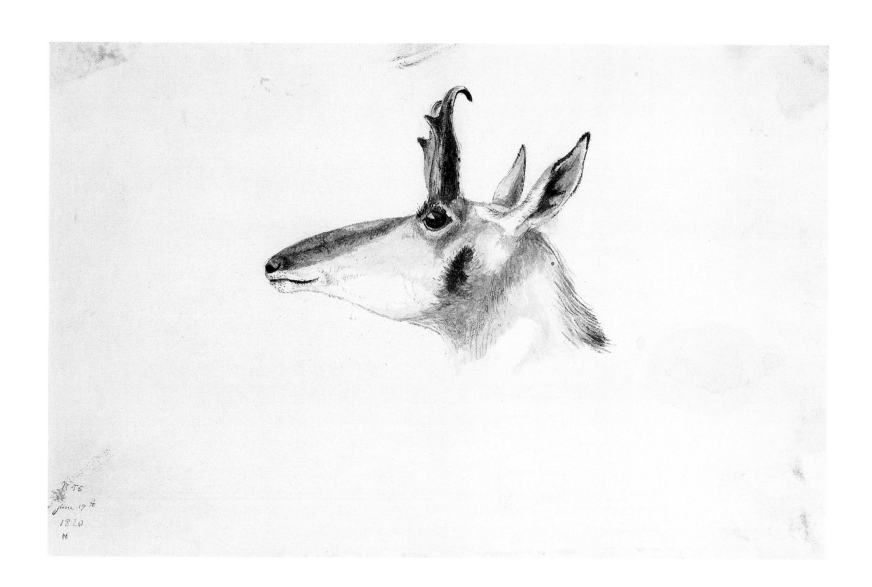

67. Titian Ramsay Peale, *Antelope (head)*, 1820. Watercolor, 5 × 7⅞ inches. American Philosophical Society, Philadelphia, Pa.

68. Samuel Seymour, *View of the Rocky Mountains on the Platte 50 Miles from Their Base*, 1821. Engraving, 5⅝ × 8⅝ inches. Amon Carter Museum, Fort Worth, Tex.

69. Samuel Seymour, *Cliffs of Red Sandstone near the Rocky Mountains*, 1820. Watercolor, 5⅝ × 8 inches.
The Beinecke Rare Book and Manuscript Library, Yale University, New Haven, Conn.

70. Samuel Seymour, *View of James Peak in the Rain*, 1825. Pen and watercolor, 4⅜ × 8 inches.
Museum of Fine Arts, Boston, Mass. M. and M. Karolik Collection.

71. Samuel Seymour, *Pawnee Indian Council*, 1819. Watercolor, 5⅞ × 8 inches.
The Beinecke Rare Book and Manuscript Library, Yale University, New Haven, Conn.

72. Albert Bierstadt, *The Buffalo Trail*, ca. 1867. Oil on canvas, 32 × 48 inches.
Museum of Fine Arts, Boston, Mass. Gift of Martha C. Karolik for the M. and M. Karolik Collection of American Paintings, 1815–65.

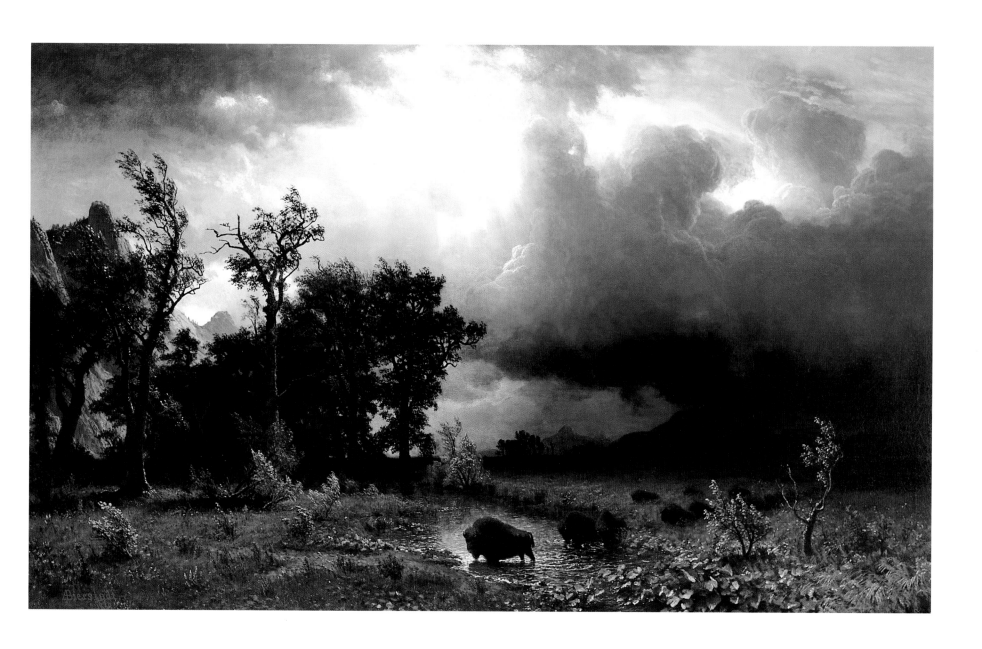

73. Albert Bierstadt, *Buffalo Trail: The Impending Storm,* 1869. Oil on canvas, 29½ × 49½ inches.
The Corcoran Gallery of Art, Washington, D.C.

74. William Jacob Hays, *The Stampede* (original study), n.d. Oil on canvas, 8½ × 12⁵⁄₁₆ inches.
Glenbow Museum, Calgary, Alberta, Canada. Glenbow Collection (59.16.74).

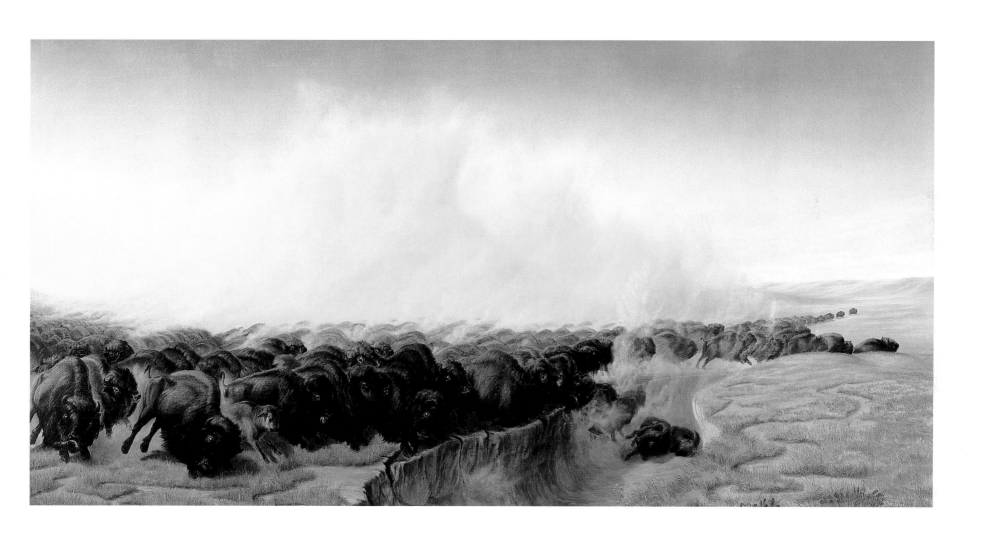

75. William Jacob Hays, *The Stampede,* 1862. Oil on canvas, 36 × 72⅛ inches.
Glenbow Museum, Calgary, Alberta, Canada. Glenbow Collection (57.27).

manners, and customs of Native American peoples was George Catlin. While his works are frequently criticized as lacking artistic virtuoso, Catlin was driven more by a desire for meticulous documentation than by aesthetics. His Indian gallery and his later cartoon series, watercolor sketches from memory based on his earlier paintings, together number more than nine hundred works, many accompanied by extensive ethnographic notes.[16]

A contemporary of Catlin's who was frequently in direct competition with him for congressional funding, John Mix Stanley was inspired by the efforts of earlier artist-documenters and set out to create his own Indian gallery. Stanley, like Catlin, urged the federal government to buy his body of works to preserve a visual record of the western tribes, noting that nearly the whole of his endeavor "was passed in those regions where the nature and habits of the Indians are found in their great-

est purity and originality ... a people silently retreating or melting away from before the face of civilization like exhalations from the sunlight."[17]

The art produced by King, Catlin, and Stanley present views of an age peopled by proud and independent nations as they existed in their aboriginal splendor. King's works enjoyed immediate success. Stanley's paintings were tragically lost in a fire at the Smithsonian Institution in 1865, and he spent much of his remaining life trying to recreate them. Catlin's works, while never achieving the favored status of King's, nevertheless represent the single most authoritative ethnographic record of Plains peoples from the early nineteenth century and provide a rich source of scholarly information today. All three artists gave the world a lasting visual legacy unsurpassed in their passion for accuracy and scope. *Bradley A. Finson*

77. Alfred Jacob Miller, *Buffalo Hunt*, ca. 1839. Oil on canvas, 30¼ × 50¼ inches.
Amon Carter Museum, Fort Worth, Tex. (1966.21).

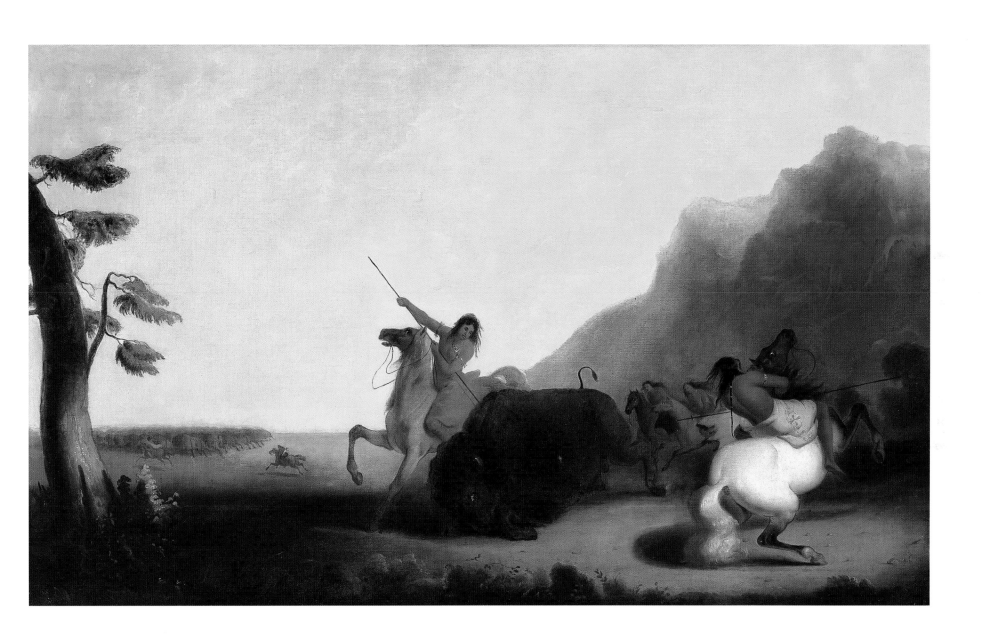

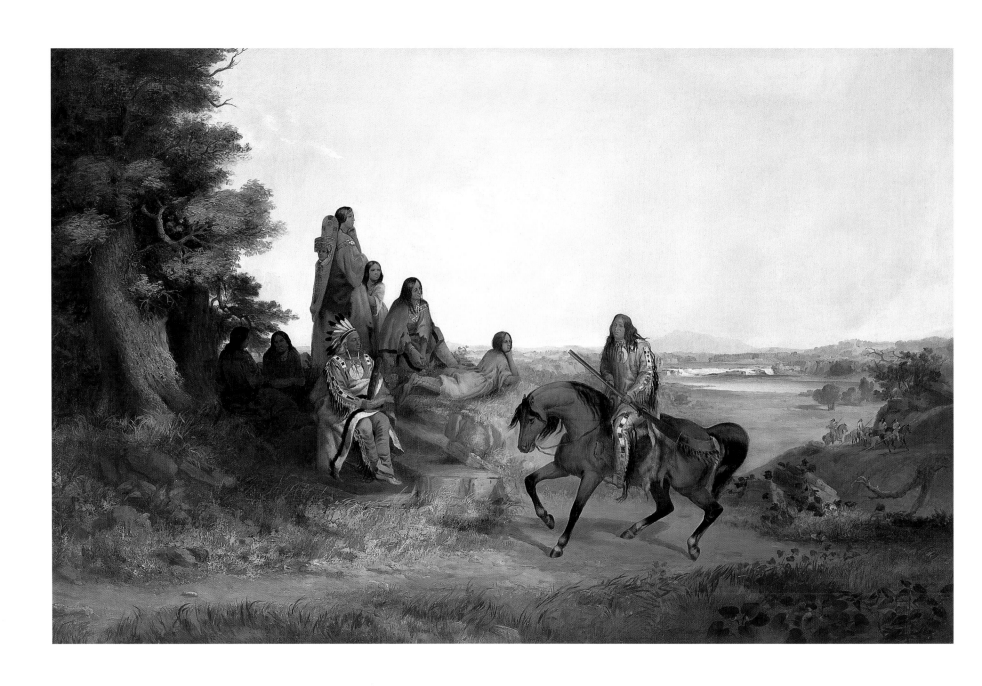

78. John Mix Stanley, *Barter for a Bride*, ca. 1854–60. Oil on canvas, 40 × 63 inches.
U.S. Department of State, Diplomatic Reception Rooms, Washington, D.C. Gift of the Morris and Gwendolyn Cafritz Foundation.

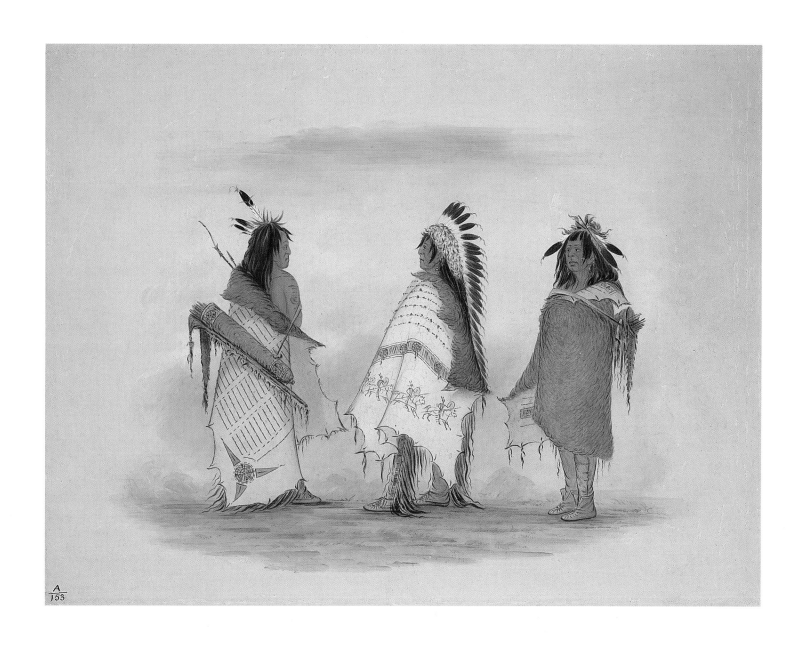

79. George Catlin, *Three Shoshoni Warriors*, 1861/1869. Oil on paperboard mounted on heavier paperboard, 17^{15}/$_{16}$ × 23¾ inches.
National Gallery of Art, Washington, D.C. Paul Mellon Collection.

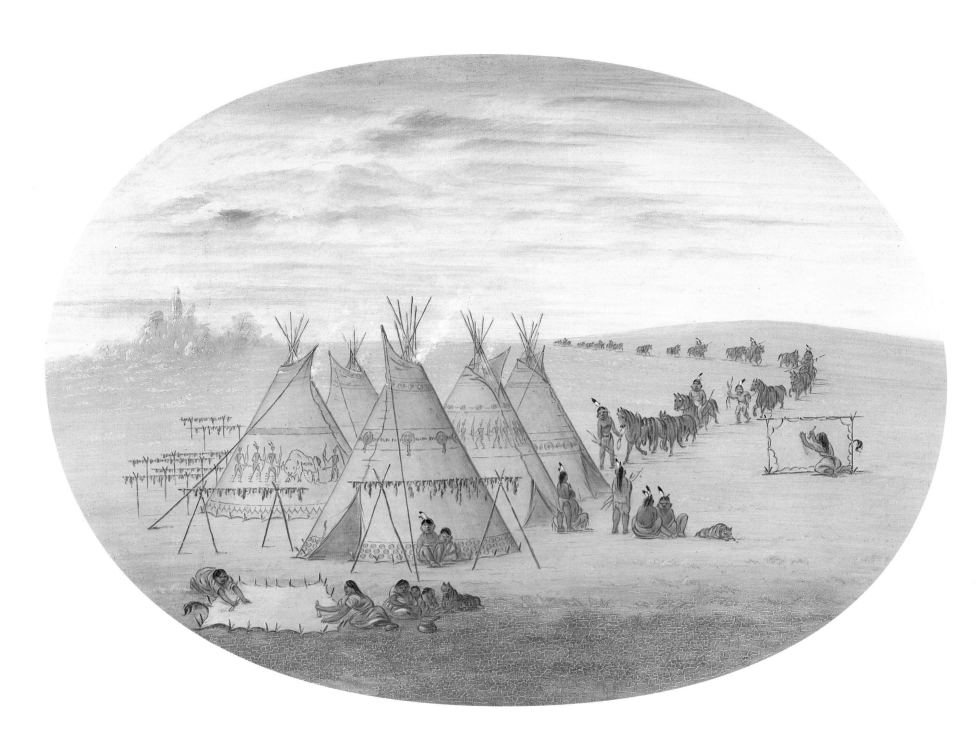

80. George Catlin, *A Little Sioux Village*, 1861/69. Oil on paperboard mounted on heavier paperboard, 18¾ × 25⅛ inches. National Gallery of Art, Washington, D.C. Paul Mellon Collection.

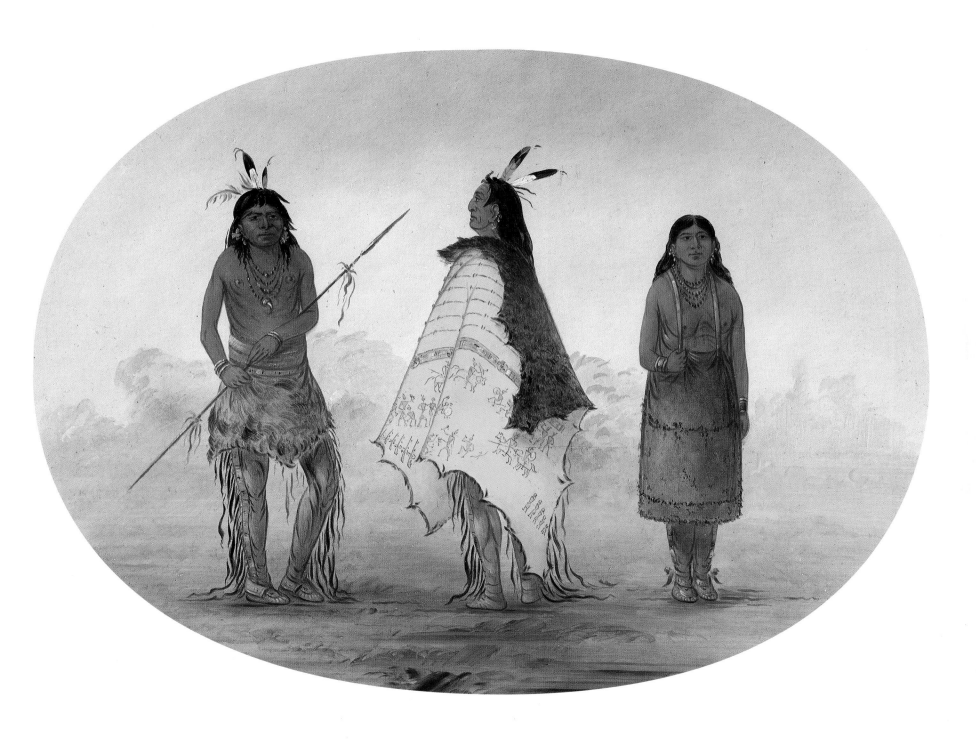

81. George Catlin. *Two Apachee Warriors and a Woman*, 1855/1869. Oil on paperboard mounted on heavier paperboard, 18⅜ × 24¼ inches.
National Gallery of Art, Washington, D.C. Paul Mellon Collection.

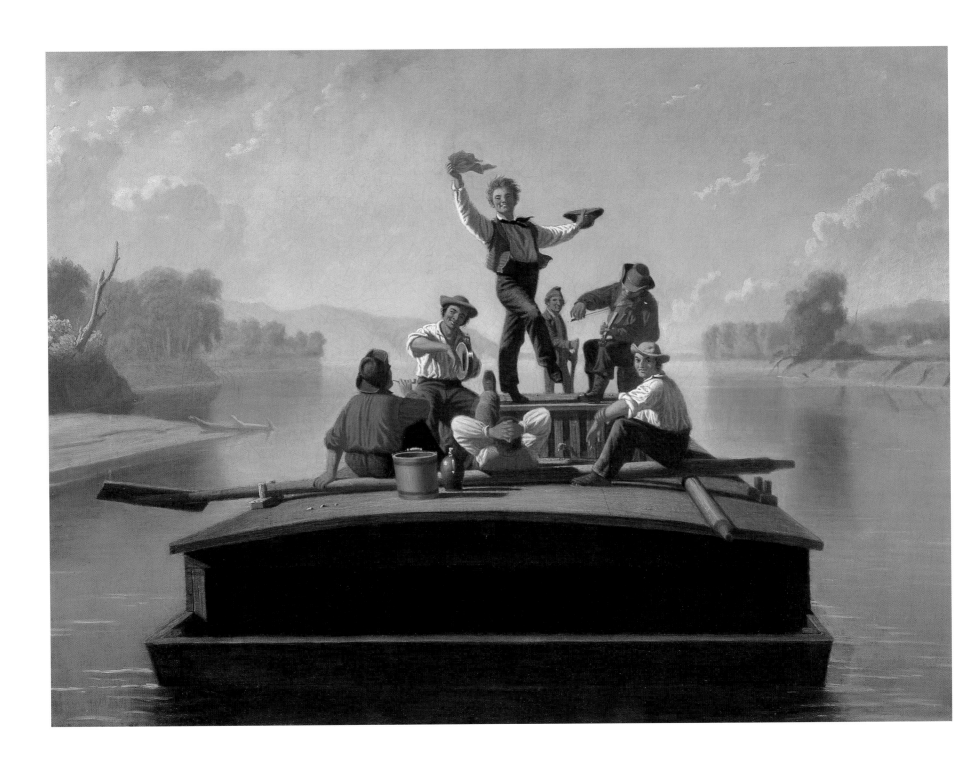

In contrast to the concept of the West as a place filled with innumerable dangers and obstacles was the idea, which emerged during the decade 1830–40, of the West as a new Eden, holding the promise of new beginnings and new life for thousands of people in the East. Central to this idea of a new Eden was the peaceful intermingling of European American and Native American cultures, as well as a reinvigoration of the American spirit.

The allure of the West for its beauty and its commercial possibilities inspired visions of renewed energy and vitality on a national scale. Images produced by artists in the early half of the nineteenth century visually portrayed individual types who had already achieved heroic status in the American mind. The mountain man, as shown in the works of Alfred Jacob Miller, and the common man, engaged in contemporary scenes epitomizing Thomas Jefferson's yeoman farmer ideal, became hallmarks of the hero to be found in America's westward expansion beyond the Mississippi River. Not only was it possible to settle new land and build a new and prosperous life, but one could also do so in peaceful coexistence with native peoples who, many believed, would eventually be assimilated into the mainstream of American society as participants in the great American dream.

Miller's painting *The Trapper's Bride* (figure 85) embodies the sentiment, held by many in the young American republic, that the benefits of European American civilization were so abundantly apparent that the uncivilized Indians would recognize and readily embrace them, becoming active partners in the development of the West.[18] In Miller's painting, the young, demure Indian woman, allegorically representing aboriginal America, is willingly given by her father to the trapper, who symbolizes the advent of civilization in the western lands. The soft, glowing light that permeates the left side of the painting is gradually moving to the right, where it will eventually displace dark, murky ignorance, symbolized by the clouds behind the mounted warrior and the Indian lodges.

George Caleb Bingham's *The Jolly Flatboatmen* (figure 82) celebrates the spirit of American accomplishment in its exuberance, extolling the prosperity and joy that the West's bounty will afford its new caretakers. The scene is a thriving riverfront town, as evidenced by the steamboat at the far right, under a serene blue sky. Surrounded by tokens of the West's bounty, the participants joyously indulge in song and dance to celebrate their good fortune.

Miller's and Bingham's paintings provided a positive vision for the young American nation. For those who were willing to participate in capturing the untapped wealth and potential of the West, only benefits awaited their diligent efforts.

Bradley A. Finson

82. George Caleb Bingham, *The Jolly Flatboatmen*, 1877–78. Oil on canvas, 26 1/16 × 36 3/8 inches.
Terra Museum of American Art, Chicago, Ill. Terra Foundation for the Arts, Daniel J. Terra Collection, 1992.

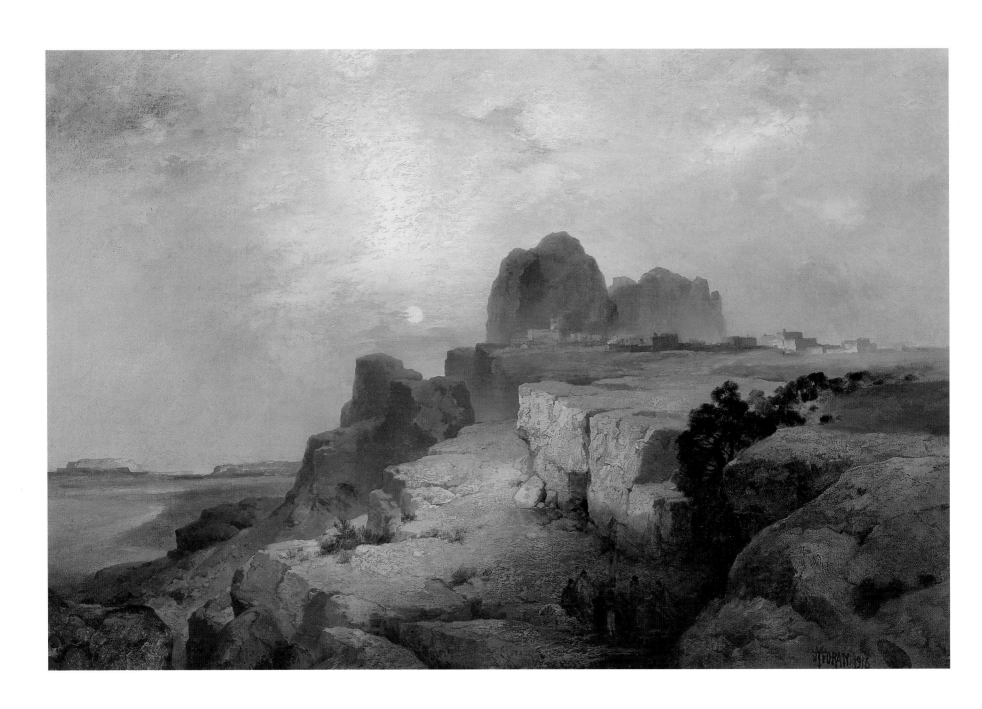

83. Thomas Moran, *Hopi Village, Arizona,* 1916. Oil on canvas, 20 × 30 inches. Heckscher Museum of Art, Huntington, N.Y.

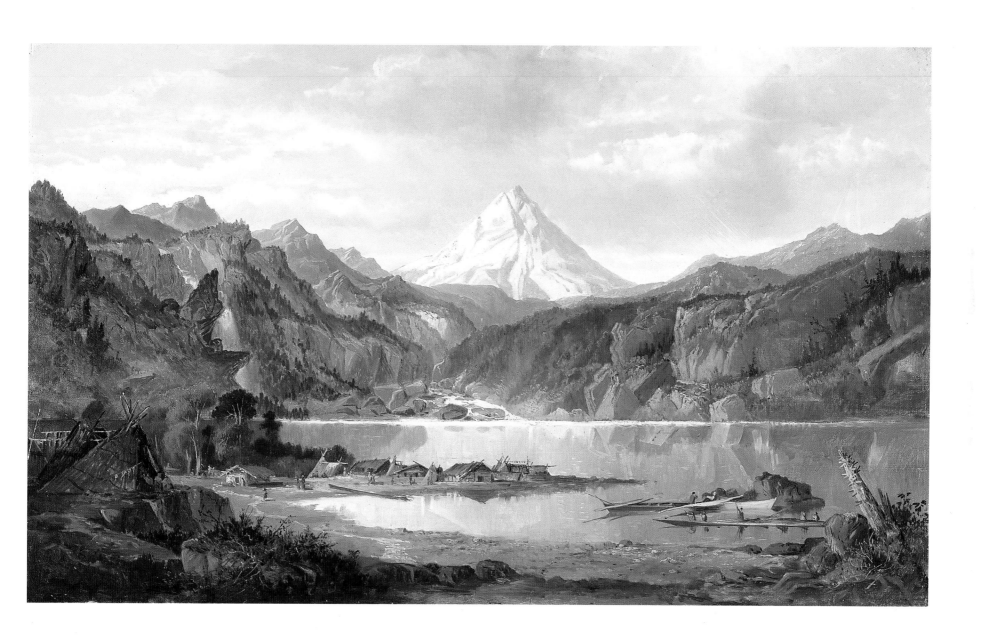

84. John Mix Stanley, *Mountain Landscape with Indians,* early 1870s. Oil on canvas, 18 × 30 inches.
The Detroit Institute of Arts, Detroit, Mich. Gift of the Wayne Medical Society.

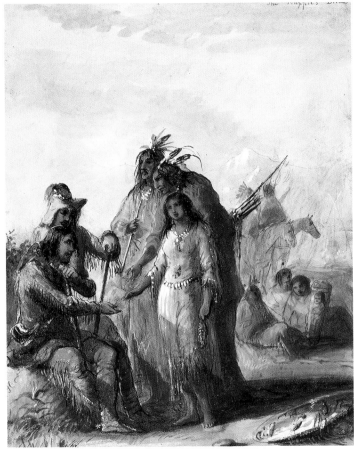

85

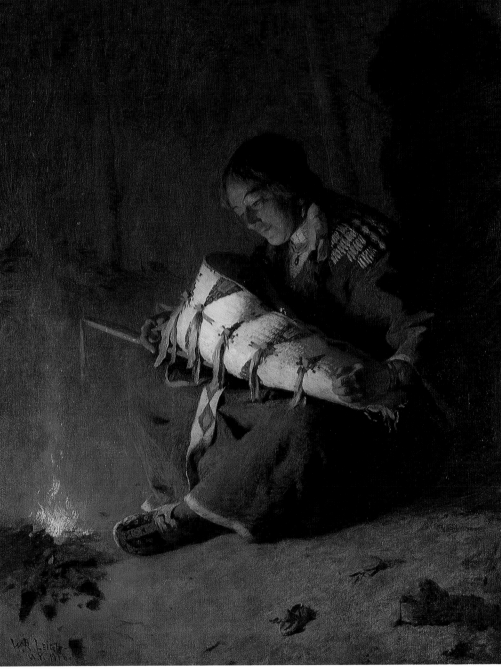

86

87

85. Alfred Jacob Miller, *The Trapper's Bride,* ca. 1837. Watercolor, 8¾ × 10¾ inches. Gilcrease Museum, Tulsa, Okla.

86. William Robinson Leigh, *Lullaby,* 1918. Oil on canvas, 28 × 22 inches.
Collection Fred Jones Jr. Museum of Art, The University of Oklahoma, Norman, Okla. Purchase Richard H. and Adeline J. Fleischaker Collection, 1996.

87. Charles Deas, *The Voyageurs,* 1846. Oil on canvas, 13 × 20½ inches. Museum of Fine Arts, Boston, Mass.
Gift of Maxim Karolik for the M. and M. Karolik Collection of American Paintings, 1815–65.

CULTURES IN CONFLICT

The increased contact between Anglo-Americans and Native Americans in the West in the 1840s and 1850s was accompanied by escalating competition for its resources. The world views of Native Americans were diametrically opposed to those of nineteenth-century European Americans, and these differences were exacerbated by their conflicting approaches to the use of natural resources. As hunger for new territory and untapped resources in land, minerals, and timber intensified, it became increasingly evident that there was not enough room in the West for both societies. A number of artists, fueled by patriotic fervor, portrayed the hostility between the two groups. Anglo-Americans regarded Native Americans as just another element of the untamed landscape to be subdued; Native Americans, in turn, engaged in the violent expulsion of the white invaders from their tribal territories.

During the height of westward expansion, from the 1840s through the 1860s, the concept of the Indian as an avaricious, implacable foe became a national statement that sanctioned America's Manifest Destiny to the vast territories beyond the Mississippi River. Several artists, including Emanuel Gottlieb Leutze, Carl Wimar, Leopold Grozelier, and Theodore Davis, produced works that cast immigrants and settlers as innocent victims, their sole intent to extend the bounds of civilization into the wilderness of the trans-Mississippi West, yet assailed by ferocious Indians. Many works of the period sought to infuse immigration to the West with a sense of high drama. Wimar's *Attack on an Emigrant Train* (figure 88) was probably intended for a particularly wide audience who would sympathize with the hapless defenders fighting off the ruthless onslaught of wild tribesmen. Such portrayals

88. Carl (Charles) Wimar, *The Attack on an Emigrant Train*, ca. 1856. Oil on canvas, 55 × 79 inches. University of Michigan Museum of Art, Ann Arbor, Mich. Bequest of Henry C. Lewis.

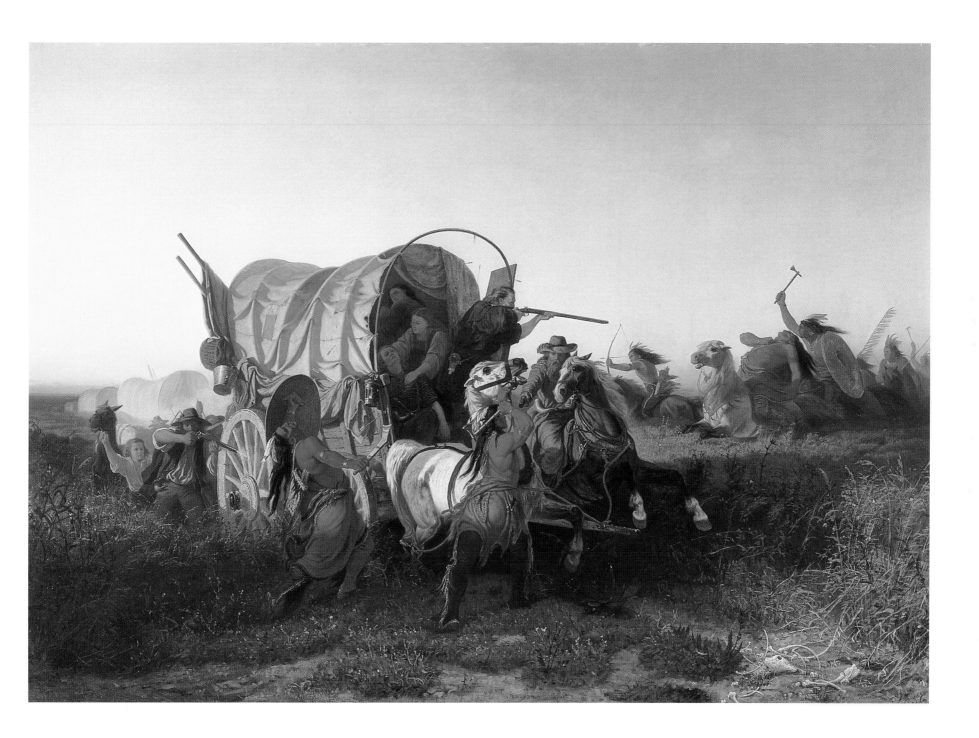

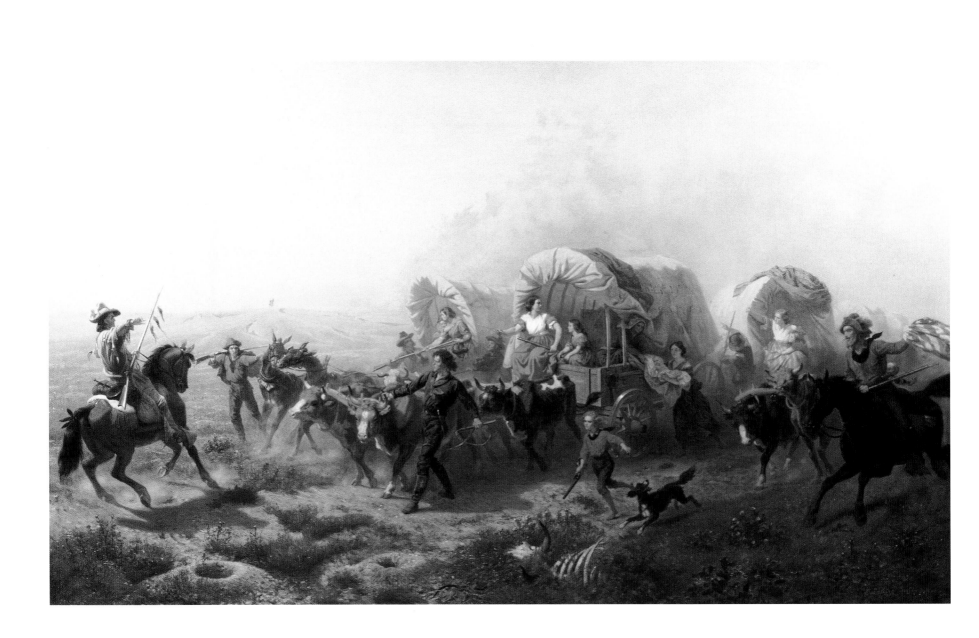

reinforced the illusion of the West as requiring deliverance and served as a justification of westward expansion.

Working as an artist-correspondent for *Harper's Weekly,* Theodore Davis produced works such as his wood engraving *On the Plains—Indians Attacking Butterfield's Overland Dispatch Coach* (figure 4), reinforcing the theme of the invader as victim. Attacked by hordes of Indians portrayed as anonymous figures, the mule-drawn coach is placed against a stark white outcropping, focusing attention firmly on the besieged. The period's popular literature was filled with similar images, later supplanted by the twentieth-century film and television "western."

In the process of acquiring the new western territories, European Americans became increasingly antagonistic toward Native Americans. Works by artists such as William Ranney, Charles Deas, and Arthur Fitzwilliam Tait expressed an increasingly anti-Indian bias. Frequently, the adversary was a pervasive but unseen element that was only hinted at or left to the viewer's imagination, as in Ranney's *The Trapper's Last Shot* (figure 92). Other compositions, such as Tait's *The Last War Whoop* (figure 90), overtly alluded to civilization's conquest of the savage and barbarous. The tension and drama portrayed in such works fed the young American nation's sense of purpose and successfully promoted its Manifest Destiny. This spirit of determinism, regardless of the cost, is dramatically portrayed in Deas's *The Death Struggle* (figure 91), in which the Indian antagonist savagely wrestles with the trapper on the edge of a precipice. Both combatants will certainly plunge to their deaths in the chasm below them, the foreboding, stormy sky underscoring their impending fate.

Bradley A. Finson

89. Emanuel Leutze, *Indians Attacking a Wagon Train,* 1863. Oil on canvas, 67½ × 40 inches. Dover Public Library, Dover, N.J.

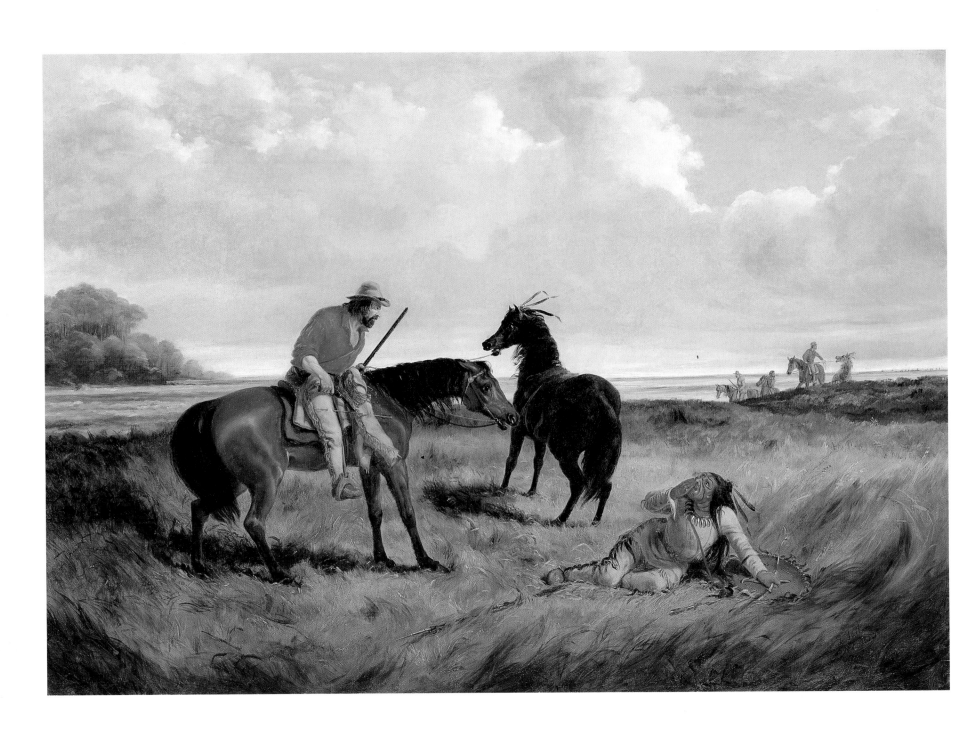

90. Arthur Fitzwilliam Tait, *The Last War Whoop*, 1855. Oil on canvas, 30 × 44 inches.
Milwaukee Art Museum, Milwaukee, Wis. Gift of Edward S. Tallmadge as a memorial to the men who loyally and selflessly gave their lives for our country in World War II.

91

92

91. Charles Deas, *The Death Struggle,* 1845. Oil on canvas, 30 × 25 inches. Shelburne Museum, Shelburne, Vt.

92. William Ranney, *The Trapper's Last Shot,* 1850. Steel engraving by T. Dwight Booth, 18 × 24 inches. Bancroft Library, University of California, Berkeley, Calif.

THE MINUTE VERSUS THE GRAND

The English art critic John Ruskin influenced a generation of late-nineteenth-century artists across two continents with his writings that preached the importance of direct observation of nature and the desirability of creating the sublime and the picturesque in landscape painting. A champion of the great romantic landscapist J.M.W. Turner, he urged other artists to study closely this painter's striking treatment of color and light. Many of the artists who painted America's Far West during its age of exploration, whether they had actually read Ruskin or not, were influenced by this persuasive writer.

A follower of Ruskin's teachings and an admirer of Turner's transcendental scenery, Thomas Moran set out with the geologist Ferdinand V. Hayden on the first official survey of Yellowstone in 1871. Paintings such as *Lower Falls of the Yellowstone* (figure 98) established Moran's fame and led to Yellowstone's becoming the country's first national park. Moran's skill at fashioning light and atmospheric effects (like his contemporary Sanford Robinson Gifford in *Long's Peak, Colorado, September 20, '70*, seen in figure 93), his vigorous use of color, and his portrayal of grand, sweeping views epitomized Ruskin's notion of the sublime. In recreating his breathtaking views, Moran relied on his own field sketches (figure 97), often with extensive notes on color, as well as William Henry Jackson's photographs, but it is clear that he allowed his personal vision to override reality. Moran believed that as long as the artist relied on nature to guide his subjects, he could take whatever artistic license he felt necessary.

Thomas Hill shared Moran's taste for inspired panoramic views, and his capacious landscapes such as *Yosemite Valley* (from below Sentinel Dome, as Seen from Artist's Point) (figure 99) were often compared to those of his younger contemporary. While glorifying nature, Hill too did not endeavor

93. Sanford Robinson Gifford, *Long's Peak, Colorado, September 20, '70*, 1870. Oil on canvas, 6¼ × 13½ inches. Arthur J. Phelan.

to paint its environment as it actually appeared. His unique manner of applying paint in angular strokes using a large brush obscured details and allowed for what the artist called "accidental effects," elements he thought necessary to the success of his work. [12]

The painter and etcher John Henry Hill (no relation to Thomas Hill) arrived at quite a different solution to the challenge posed by Ruskin and his followers. Thanks to his artist father, John Henry had been exposed early to Ruskin's writings and took these lessons to heart, devoting his entire painting career to working directly and faithfully from nature. In 1868 Hill was hired as the artist on Clarence King's fortieth parallel survey to the Shoshone River region. King himself was also a follower of Ruskin's ideology and along with Hill and his father had formed the first Pre-Raphaelite movement in the United States. This group, formally known as the Society for the Advancement of Truth in Art, espoused Ruskinian views and in its journal *New Path* encouraged artists to exalt "all forms in nature from the great mountains to the humblest weed."[13]

Whereas Moran and Thomas Hill arrived at an idealized beauty in their finished paintings, John Henry Hill's works, while ideologically similar, present settings free of superfluous grandeur. Within the diminutive dimensions of *Shoshone Falls* (figure 95), one of Hill's paintings from the King survey, the artist provided a bird's-eye view of one of nature's most impressive sights. The waterfall and rock faces are precisely delineated, their colors muted and neutral, and the entire composition is tightly controlled. By altering his own vantage point, Hill thus removed any trace of the artist. In his unwavering reverence for nature, he chose to create a desolate and pristine vista free of inhabitants or embellishment.

Stephanie Foster Rahill

94. Thomas Worthington Whittredge, *Little Blue River*, 1866. Oil on canvas, 8⅜ × 23 inches. Autry Museum of Western Heritage, Los Angeles, Calif.

95. John Henry Hill, *Shoshone Falls*, 1871. Watercolor, 12 × 17½ inches. Arthur J. Phelan.

96. Thomas Moran, *Shoshone Falls, Snake River, Idaho,* ca. 1875. Watercolor on paperboard, 10 × 14 inches.
Chrysler Museum of Art, Norfolk, Va. Gift of Hugh Gordon Miller.

97. Thomas Moran, *Yellowstone Lake,* 1871. Watercolor, 5 × 12 inches. Jefferson National Expansion Memorial, National Park Service, St. Louis, Mo.

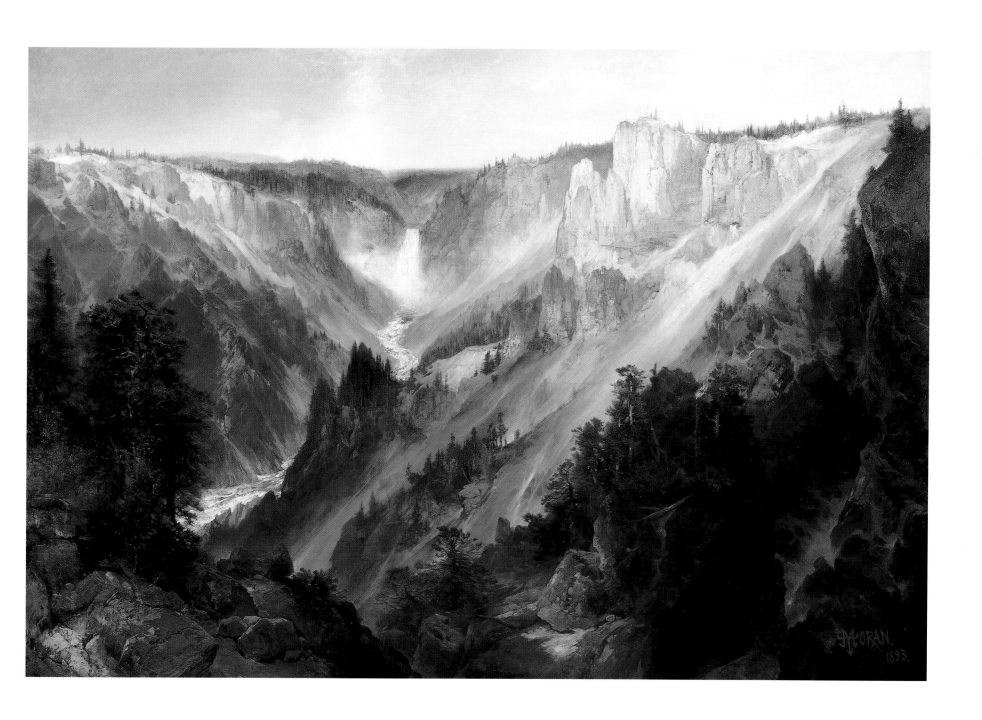

98. Thomas Moran, *Lower Falls of the Yellowstone*, 1893. Oil on canvas, 40½ × 60¼ inches. Gilcrease Museum, Tulsa, Okla.

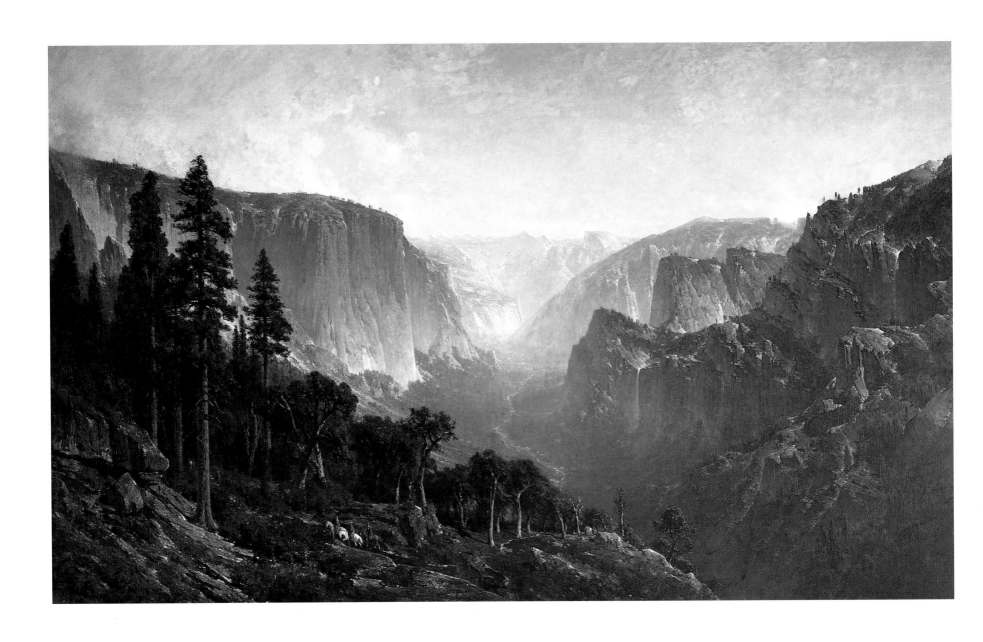

99. Thomas Hill, *Yosemite Valley* (from below Sentinel Dome, as Seen from Artist's Point), 1876. Oil on canvas, 72 × 120 inches.
Oakland Museum of California, Oakland, Calif. Kahn Collection.

100. Thomas Worthington Whittredge, *In the Rockies*, 1865. Oil on canvas, 14½ × 20 inches.
The Harmsen Museum of Art, Denver, Colo. William and Dorothy Harmsen Collection.

101. Albert Bierstadt, *Nebraska Territory, Wasatch Mountains, View of South Pass, Wyoming*, 1859.
Oil on paper mounted on board, 13 × 19 inches. Arthur J. Phelan.

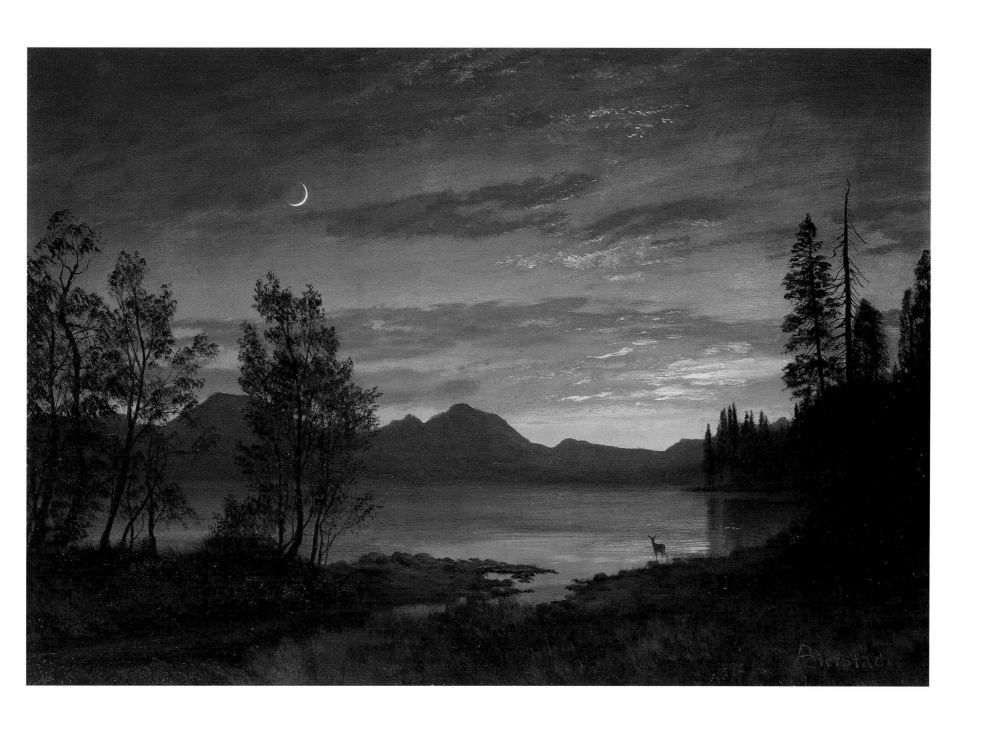

102. Albert Bierstadt, *Twilight, Lake Tahoe*, ca. 1873. Oil on millboard, 14 × 20 inches.
U.S. Department of State, Diplomatic Reception Rooms, Washington, D.C. Gift of Senator William Hernstadt and Judith Hernstadt.

The 1890 census, documenting the rapid population growth of the western states, underscored the fact that the frontier as a specific geographical place officially no longer existed. In his *Frontier in American History* (1920), Frederick Jackson Turner expounded his view that the loss of free land signaled the end of the frontier in America. The demise of the West as an arena for flexing expansionist muscle was much lamented in the works of various turn-of-the-century artists. The images of western art became icons of nostalgic references to a way of life that had forever passed, an adventure destined to live on only in imagination and myth.

In an undated letter to his contemporary Carl Rungius, Frederic Remington observed: "We fellows who are doing the 'Old America' which is so fast passing will have an audience in posterity whether we do at present or not."[22] Remington, Albert Bierstadt, Henry Farny, and other artists in the closing years of the nineteenth century presented a West that lived on in the hearts and imaginations of their audience. But the West of reality no longer included the dashing cavalryman, the chivalrous cowboy, or the proud and defiant Indian, all of whom lived only on canvas and in memory.

The West portrayed by turn-of-the-century artists is epitomized in Charles M. Russell's watercolor *Buffalo Herd at Bay*. Where once vast bison herds had darkened the plains, by the 1870s the buffalo were reduced to a few hundred. Eventually, although celebrated as an icon on coins, they came close to extinction and now graze behind barbed-wire fences within the boundaries of national parks. The West they had so widely inhabited was only a memory, lost before the encroaching tide of progress.

This theme is echoed in Farny's painting *Rounded Up by God* (figure 105). The lone cavalryman standing beside his fallen horse resignedly contemplates his death as the enemy surrounds him. Farny's piece is not so much about the conflict between Indians and European Americans or the desperate stand of the sole survivor in a savage land as it is about the savage land itself, whose own survival is doomed. The figure's placement against a barren foreground expresses a sense of loneliness and the loss of a time and place that no longer exist except in the imagination and memory of those portraying it.

Remington is the paramount memorializer of the West that has passed. His wood engraving *The Last Lull in the Fight* (figure 104) depicts three herders who stoically await the final assault by the enemy, the emptiness of the surrounding landscape only emphasizing the sense of impending demise. Underlying the primary narrative of the scene is the conviction that progress has sounded the death knell for the West of American fantasy and imaginative longing.

Bradley A. Finson

103. Cyrus Edwin Dallin, *Appeal to the Great Spirit,* ca. 1916–20. Bronze, 21½ x 15 x 20½ inches. U.S. Department of State, Diplomatic Reception Rooms, Washington, D.C. Gift of Mr. Philip L. Poe.

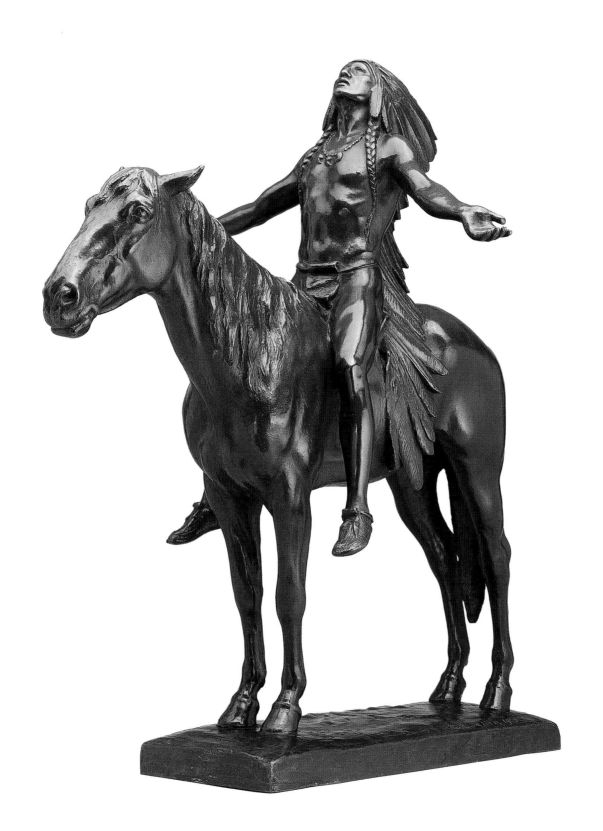

104. Frederic Remington, *The Last Lull in the Fight*, 1889. Wood engraving, 15 × 22 inches.
Collection of Mississippi Museum of Art, Jackson, Miss. Purchase.

105. Henry Farny, *Rounded Up by God,* 1906. Oil on canvas, 19½ × 39½ inches.
American Heritage Center, University of Wyoming, Laramie, Wyo.

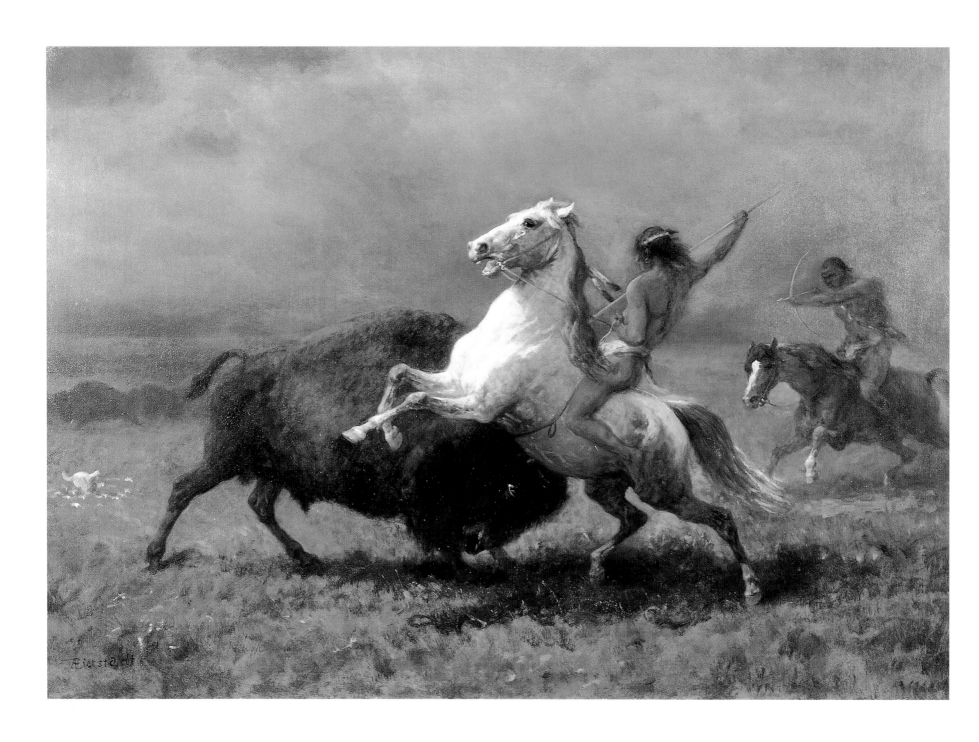

106. Albert Bierstadt, *Indians Hunting Buffalo*, ca. 1888. Oil on canvas, 24¾ × 35⅞ inches.
Fine Arts Museums of San Francisco, San Francisco, Calif. Gift of Mr. and Mrs. John D. Rockefeller 3rd, 1979.

107. Charles M. Russell, *Buffalo Herd at Bay,* 1901. Watercolor on paper, 11¼ × 17⅜ inches.
U.S. Department of State, Diplomatic Reception Rooms, Washington, D.C. Gift of Mr. and Mrs. John A. Hill.

PHANTOM HEROES

In the later art of the American West, the cowboy quickly assumed prominence as an icon. Frederic Remington and Charles M. Russell established the image in the American mind as being larger than life, unbridled and free of social restraint. Remington's painting *Ghosts of the Past* (figure 108) casts the cowboy, as part of a continuing western chivalric tradition, battling alien cultures representing everything counter to European American civilization.

In sharp contrast to images of the cowboy's chivalric mission and the reality of his harsh, unglamorous life are works by Russell such as *Bronc in Cow Camp* (figure 112), which emphasizes the irrepressible playfulness, adventure, and romanticism that was also part of his life. This fabricated world invaded the American consciousness in much the same way that Russell's bronco explodes into the cow camp: in a dramatic display of the dynamic energy that symbolized the American character in the eyes of the world.

In addition to such unbridled energy, Russell's western works also depict a solemn nobility, as expressed in his painting *His Heart Sleeps* (figure 2). This composition metaphorically reflects a sense of continuity, as the buffalo herd follows an age-old course in its meanderings that take it beneath the Indian burial scaffold lodged in a tree. In this work death and life coexist, as Peter Hassrick notes: "While the burial scaffold in the tree represents loss and quiescence, the buffalo pouring forth from the prairies into the river offer a sense of hope for a future possibly replenished by the resources of the past."[23] Indeed, such images of a past long gone regenerated hope in an American nation that looked to its phantom heroes for inspiration as it strode into a new century. *Bradley A. Finson*

108. Frederic Remington, *Ghosts of the Past,* ca. 1909. Oil on canvas, 12 × 16 inches.
Buffalo Bill Historical Center, Cody, Wyo. Gift of The Coe Foundation.

109. Frederic Remington, *The Snow Trail*, 1908. Oil on canvas, 27 × 40 inches.
Frederic Remington Art Museum, Ogdensburg, N.Y. Gift of the Remington Estate.

110. E. Irving Couse, *The Sentinel,* 1912. Oil on canvas, 46 × 35 inches.
Courtesy of Gerald Peters Gallery, Santa Fe, N.M.

111. Charles M. Russell, *Medicine Man,* 1916. Oil on canvas, 22⅛ × 17⅛ inches.
Jack S. Blanton Museum of Art, The University of Texas at Austin, Austin, Tex. Gift of C. R. Smith, 1976.

112. Charles M. Russell, *Bronc in Cow Camp*, 1897. Oil on canvas, 20⅛ × 31¼ inches.
Amon Carter Museum, Fort Worth, Tex.

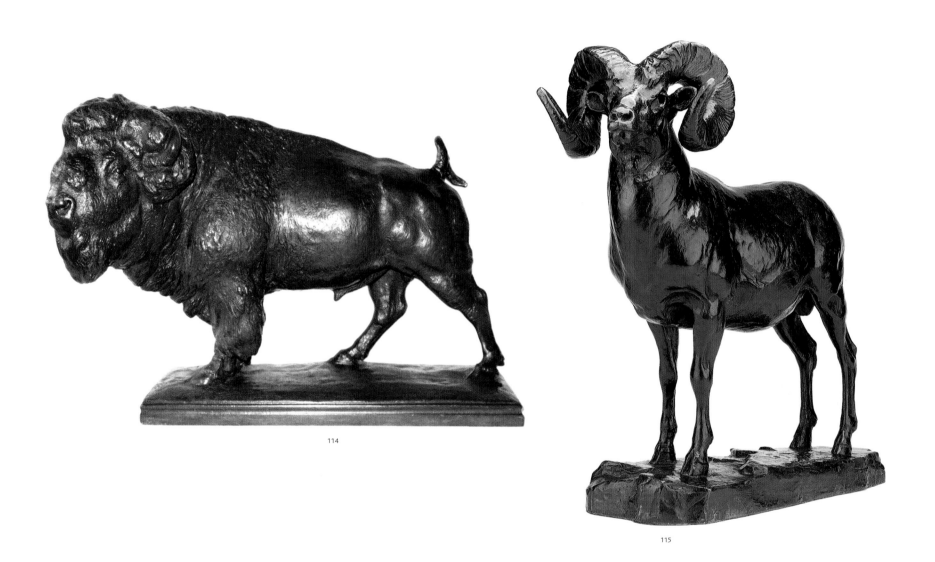

113. Henry M. Shrady, *Elk Buffalo (Monarch of the Plains),* 1900. Bronze, 23 × 28 × 8 inches.
Frederic Remington Art Museum, Ogdensburg, N.Y. Gift of the Remington Estate.

114. Alexander Phimister Proctor, *Buffalo* (model for Q Street Bridge, Washington, D.C.), 1912.
Bronze, 13¼ × 18¾ × 9½ inches. Arthur J. Phelan.

115. Carl Rungius, *Ram Sheep,* 1915. Bronze, 16½ × 7 × 17 inches.
JKM Collection, Courtesy of the National Museum of Wildlife Art, Jackson Hole, Wyo.

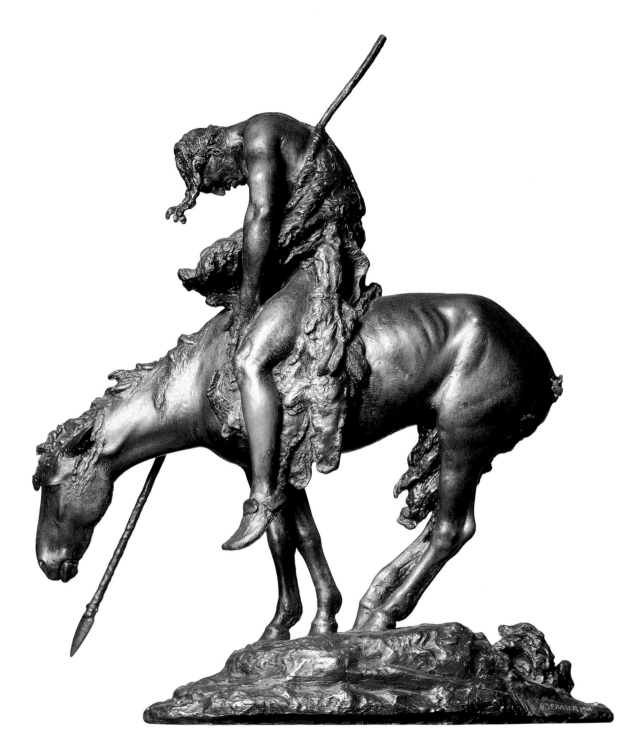

116. James Earle Fraser, *The End of the Trail*, 1918. Bronze, 30⅜ × 22 × 23 inches.
Collection of The Nelson-Atkins Museum of Art, Kansas City, Mo. Exhibited work on loan from the Dallas Museum of Art, Dallas, Tex.

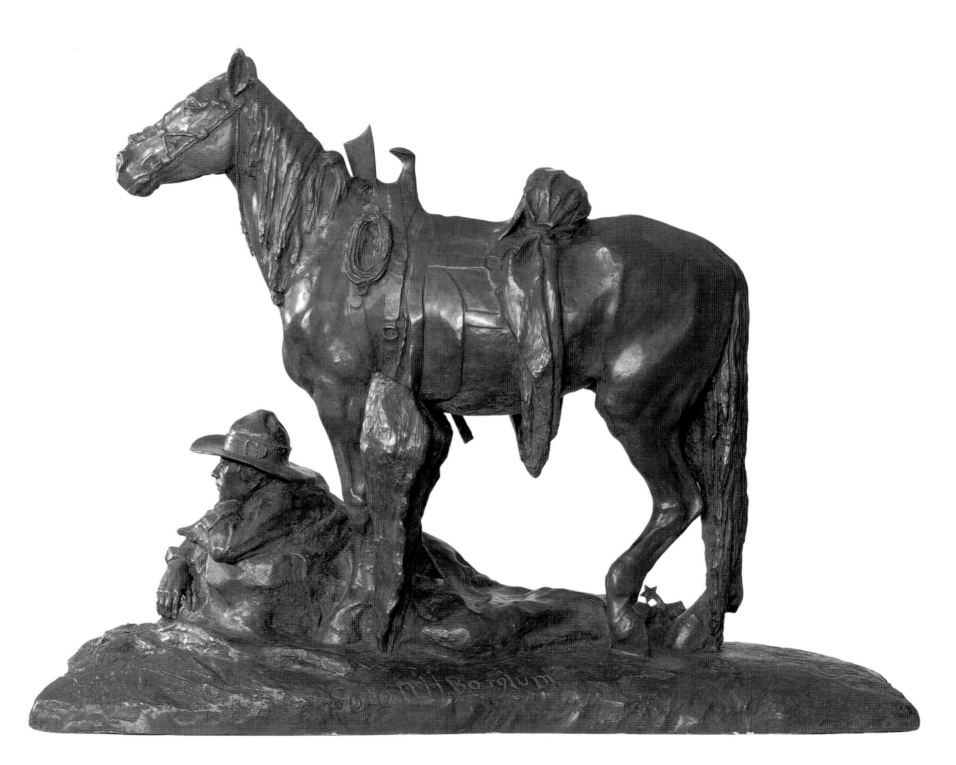

117. Solon Borglum, *Cowboy at Rest,* 1904. Bronze, 40 × 55 × 19 inches.
The New Britain Museum of American Art, New Britain, Conn. Solon H. Borglum Sculpture and Foundation Fund (1974.67).

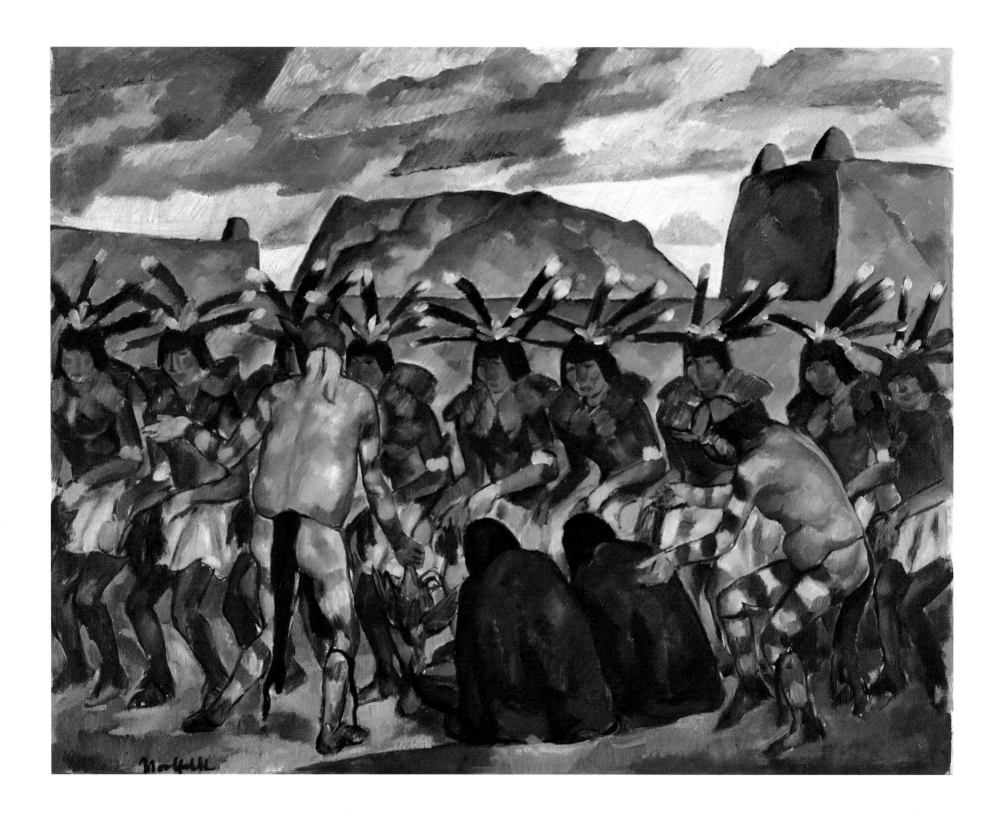

MODERNISM AND THE INDIAN

In the early 1800s Indians were alternately and collectively portrayed as aggressive attackers, noble savages, or a defeated race. This portrayal continued into the era of westward expansion, catering to a popular taste for images that reflected the Anglo-American idea of Manifest Destiny. Artists who traveled to the West in the early twentieth century were informed by modernist ideas and tended to portray Indians differently from their earlier counterparts. A majority ended up in the Southwest, attracted by its stimulating artistic climate, unusual and austere environment, and—to them—mysterious indigenous people.

Robert Henri, considered one of the most influential teachers and painters of the twentieth century, first visited Santa Fe in 1916. Before this visit, he had established a reputation as the leader of a group of New York artists known as The Eight. Focused on painting everyday life as it actually appeared, this group shocked its contemporary audience with the realism of matter-of-fact depictions of lower-class environs. Although his work reflected this modern realist dogma, Henri was above all a portrait painter whose style revealed the perceptual and stylistic influence of Frans Hals, Diego Velázquez, Francisco Goya, and Edouard Manet.

In New Mexico Henri was fascinated by the "exotic" cultures represented by the indigenous Hispanics and Pueblo Indians.

So enchanted was he that he made them his principal subjects on his many returns to Santa Fe during the next several years. Henri's portraits of Indians, unlike those of his contemporary Joseph Henry Sharp (figures 121 and 122), were not intended to be ethnographic or overly sentimental. Instead, he endeavored to capture the individual personality and inherent human dignity of each sitter. *Ricardo* (figure 119), one of nearly a hundred portraits Henri painted on his first visit, succeeds in this endeavor. In this close-up view of a San Ildefonso boy, Henri flattened and reduced details of setting and ethnic dress, focusing on subjective qualities such as the youth's downward-cast eyes and brooding disposition. Henri often included geometric elements based on Indian designs, either as a repeating pattern in the background or, as in this case, incorporated into a drape that frames the sitter. The contrast created by the blanket's bold lines and strong, solid colors, as well as its diagonal emphasis, calls further attention to Henri's painterly treatment of the face.

Until 1912, almost halfway into his painting career, Maynard Dixon had worked as an illustrator, creating nostalgic scenes of the Old West much in the same vein as his early mentor Frederic Remington. His encounters with the native peoples of Arizona and New Mexico changed his artistic outlook, prompting him to abandon nostalgic and heroic themes

118. B.J.O. Nordfelt, *Thunderdance*, 1928. Oil on canvas, 38 × 47 inches. Collection Fred Jones Jr. Museum of Art, The University of Oklahoma, Norman, Okla. Gift of Oscar B. Jacobson, 1966.

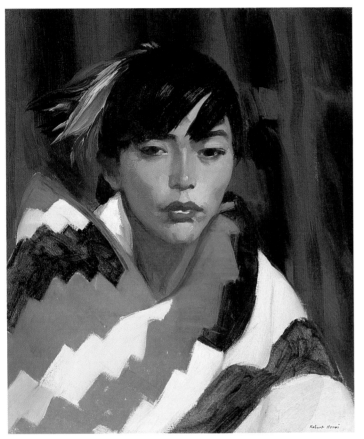

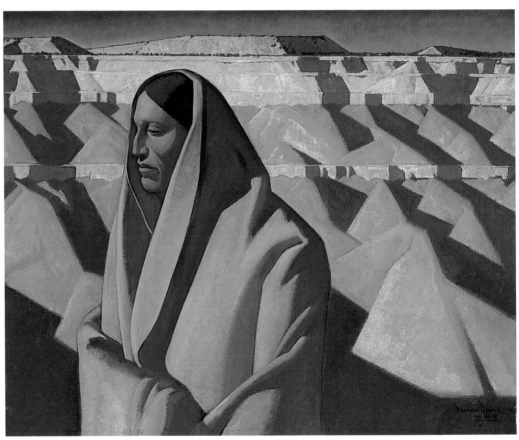

119

120

and base his paintings on present realities. Like Henri, Dixon felt a special affinity for Indians, but instead of bringing out their individual qualities he portrayed symbolic figures endowed with powerful physical and psychological presence.

Dixon's *The Earth Knower* (figure 120) depicts a stately Indian in profile against a visually stunning canyon backdrop. The natural geometric formality of southwestern topography is exaggerated, reflecting his earlier *Cubist Realist Experiment,* which does not include a figure. In *The Earth Knower,* the red dirt walls and deep ravines have been transformed into bands of alternating dark and light diagonals and repeated conical shapes that are echoed in the man's chiseled features, pyramidal profile, and heavily draped blanket. Howard Lamar aptly observed that *The Earth Knower* simultaneously projects the nineteenth-century idea of Indians in physical and spiritual harmony with nature, along with the more "modern white idea" that Indians know secrets about the earth and its people that others do not.[14] E. Martin Hennings's painting of two Indians riding slowly across a gentle landscape, *Riding Through the Sage and Cedar* (figure 123), reflects this same notion. The colors in their attire are the same as those found in the environment, and their sinuous, undulating forms are repeated in the clouds, the hills, and the mounds of sage.

B.J.O. Nordfeldt's first trip to the Southwest in 1918 became a twenty-year stay. Earlier Nordfeldt had studied art in Chicago, New York, and Paris, where he was exposed to the latest modern movements and was especially influenced by Paul Cézanne's explorations of the two-dimensional surface. The Pueblo Indians and Spanish Americans of New Mexico provided a creative stimulus for Nordfeldt's modernist ideas. Although he painted a number of portraits of Spanish Americans, he was primarily interested in Southwest Indians and the formal challenges presented in depicting their ceremonial dances.

In *Thunderdance* (figure 118), Nordfeldt conceptualized various visual elements, extracting unnecessary details to create an intricate design based on the most primary elements of the scene.[15] Using an almost monochromatic color scheme, he faceted the entire surface with stabs of arbitrary color, unifying the performers with the background. Against the solid architectural forms that appear to loom over the setting, the dynamically posed dancers seem to lunge and sway to the beat of the drums. In his paintings Nordfeldt did not attempt to characterize Indians as individuals or as monumental types but rather presented them as motifs in complex groupings that emphasized the flashing colors and driving rhythms of their vibrant rituals. *Stephanie Foster Rahill*

119. Robert Henri, *Ricardo,* 1916. Oil on canvas, 24⅛ × 20⅛ inches. University Art Museum, The University of New Mexico, Albuquerque, N.M. Museum purchase.

120. Maynard Dixon, *The Earth Knower,* 1933–35. Oil on canvas, 36 × 54 inches. Collection of the Oakland Museum of California, Oakland, Calif. Bequest of Dr. Abilio Reis.

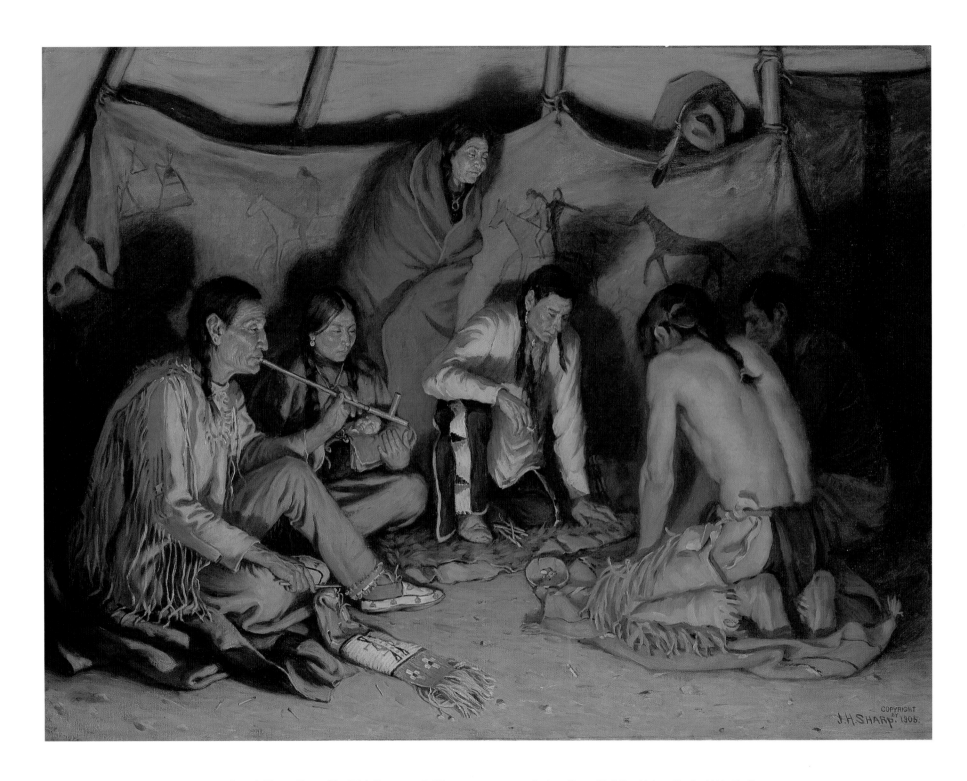

121. Joseph Henry Sharp, *The Stick Game*, 1906. Oil on canvas, 31 × 42 inches. Texas Christian University, Fort Worth, Tex.

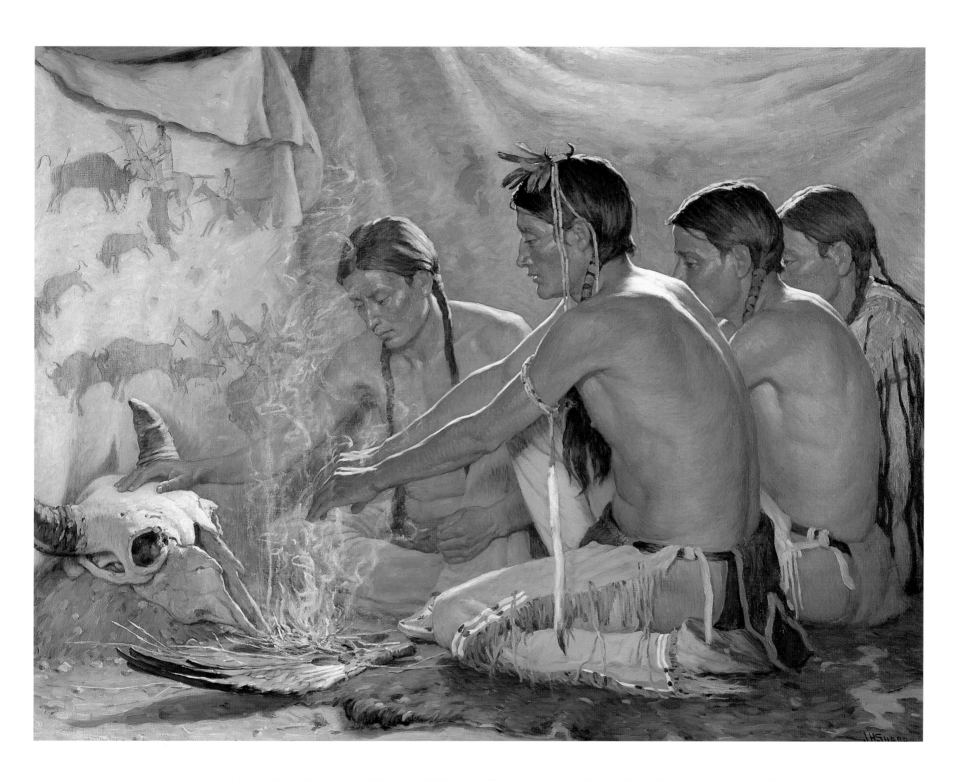

122. Joseph Henry Sharp, *Prayer to the Spirit of the Buffalo*, 1910. Oil on canvas, 30 × 40 inches. Rockwell Museum, Corning, N.Y.

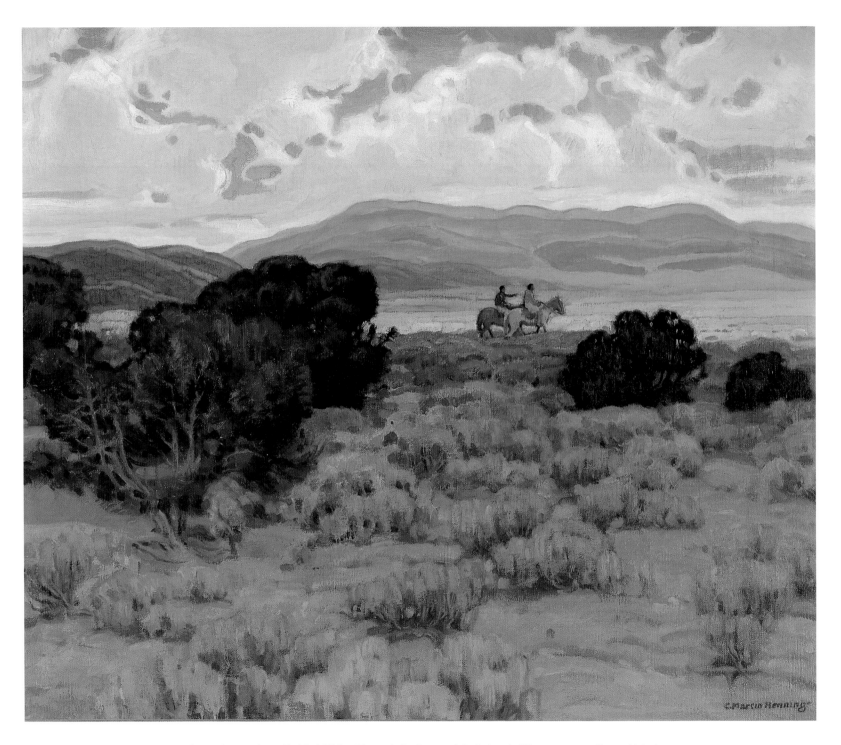

123. E. Martin Hennings, *Untitled (Riding Through the Sage and Cedar)*, n.d. Oil on canvas, 20¼ × 24¼ inches.
Museum of Fine Arts, Museum of New Mexico, Santa Fe, N.M. Gift of Miriam Harford.

124. Georgia O'Keeffe, *Ranchos Church No. 1*, 1929. Oil on canvas, 18¾ × 24 inches.
Norton Museum of Art, West Palm Beach, Fla.

Either as subjects or as artists, European American men have dominated the art of the American West. It is particularly interesting, then, to consider examples that fall outside that milieu. Grafton Tyler Brown, an accomplished nineteenth-century African-American lithographer and expeditionary artist, and Abby Williams Hill, one of the few women artists to accept major commissions from railway companies near the turn of the century, represent rare diversions from the prototype.

Grafton Tyler Brown was born in Pennsylvania in 1841. Although it is not certain when or why his family moved west, by 1861 he was employed as a lithographer in San Francisco. He soon formed his own lithography company, G. T. Brown and Company, and was also earning commissions as a traveling landscape painter.[16] An adventurous spirit, Brown journeyed throughout the northwestern states and into Canada, where he was hired as an artist on a geological expedition to the Cascade Mountains. *Mount Tacoma* (figure 125) was painted during the two years in the mid-1880s that he spent painting scenery in Washington State.

Brown's paintings have been noted for their fine attention to detail and their factual descriptions of place. The artist apparently prided himself on these very qualities, proclaiming on the cover of an 1886 catalogue advertising a group of his Yellowstone sketches:

The subjects are careful *studies from nature*. . . . The paintings produced from them will have all the truths of color of that famous locality, together with such artistic effect as will make them appreciable to all who have visited that section.

Should you desire to favor me with an order for one or more, they will receive prompt attention.[17]

The sketches contained in his catalogue are precise topographical studies of specific views of the geysers, falls, and canyons of the Yellowstone region. As indicated by his note on the catalogue, Brown would later transform these simple sketches into paintings in his studio, where he could add his own artistic enhancements.

Lured by the promised beauty of northwestern mountain scenery, Abby Williams Hill also made her way to Tacoma, Washington, in 1889. Unlike other women artists of her day

125. Grafton Tyler Brown, *Mount Tacoma* (Mount Rainier, Washington), 1885. Oil on cardboard, 10 × 20 inches. Oakland Museum of California, Oakland, Calif. Kahn Collection.

who typically focused their abilities on still lifes and flower painting, Hill had a taste for the great outdoors. A woman of means, she eschewed a conventional domestic life for one spent traveling and painting in the wilderness. During her career she received four major railway company commissions for landscapes that were circulated to regional and national expositions to promote tourism in the West. Two of her commissions took her to Yellowstone National Park, where she camped for weeks at a time and painted despite regular interruptions from park guards, inquisitive tourists, and curious bears.

In her diary, Hill commented on these encounters and wrote of the difficulty of recreating the park's extraordinary geographical features: "People will hardly believe such colors as I have painted could be true, and the weird formations look impossible. . . . How can one expect to be believed with such a combination? Yet how could one think of such coloring if Nature did not dictate."[18] Hill gauged her success on her ability to capture the true essence of nature, and, unlike Grafton Tyler Brown and her famous predecessors Thomas Moran and Albert Bierstadt, did not attempt to enlarge on it. In fact, she completed her canvases on site, considering her plein-air paintings to be her finished work.[19] Moreover, her compositions indicate a preference for cropped, intimate views of scenery as opposed to all-encompassing vistas. In response to an unwelcome suggestion that she might move to the top of a hill for a better view, Hill would later write in her journal, "Enough is as good as a feast, I did not wish to see 'the whole at once.'"[20]

Stephanie Foster Rahill

126. Abby Williams Hill, *Yellowstone Falls (View from Below),* 1905. Oil on canvas board, 37½ × 28 inches. Kittredge Art Gallery, University of Puget Sound, Tacoma, Wash. Permanent Collection.

127. Abby Williams Hill, *Yellowstone Falls (Distant View),* 1905. Oil on canvas, 38 × 28 inches. Kittredge Art Gallery, University of Puget Sound, Tacoma, Wash. Permanent Collection.

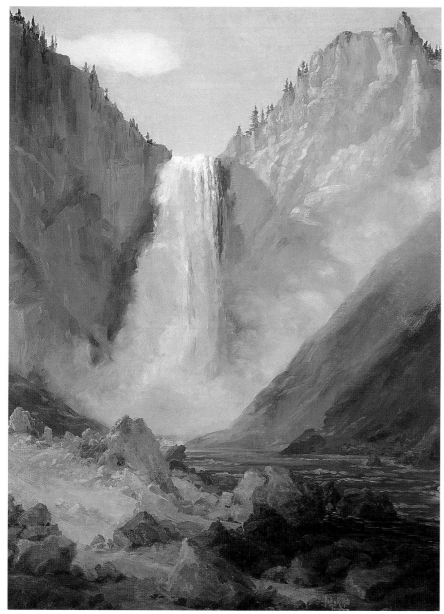

126

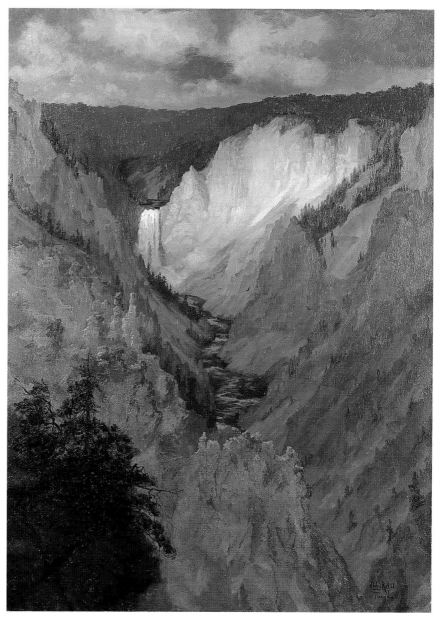

127

NOTES

1. William H. and William N. Goetzmann explore similar themes and images in *The West of the Imagination* (New York: W. W. Norton, 1986), 191–96, as does Nancy K. Anderson in her seminal essay "The Kiss of Enterprise," in *The West as America: Reinterpreting Images of the Frontier, 1820–1920,* ed. William H. Truettner (Washington, D.C.: National Museum of American Art, Smithsonian Institution Press, 1991), 248–51.

2. Corlann Gee Bush, "The Way We Weren't: Images of Women and Men in Cowboy Art," in *The Women's West,* ed. Susan Armitage and Elizabeth Jameson (Norman: University of Oklahoma Press, 1987), 17.

3. See Susan Prendergast Schoelwer, "The Absent Other: Women in the Land and Art of Mountain Men," in *Discovered Lands Invented Pasts: Transforming Visions of the American West,* ed. Jules David Prown et al. (New Haven: Yale University Press, 1992), 134–65.

4. Peter H. Hassrick, *Charles M. Russell* (New York: Harry N. Abrams, 1989), 125.

5. William H. and William N. Goetzmann, *The West of the Imagination* (New York: W. W. Norton, 1986), 166, citing a quote in David Robertson, *West of Eden: A History of the Art and Literature of Yosemite* (Yosemite National Park, 1984), 23.

6. Nancy K. Anderson, "Curious Historical Data," in *Discovered Lands, Invented Pasts: Transforming Visions of the American West,* ed. Jules David Prown et al. (New Haven: Yale University Press, 1992), 10.

7. For a full discussion of Bierstadt's promotion and exhibition of his enormous paintings (his "Great Pictures"), see Linda S. Ferber, "Albert Bierstadt: The History of a Reputation," in *Albert Bierstadt: Art and Enterprise,* ed. Nancy K. Anderson and Linda S. Ferber (Brooklyn, N.Y.: Brooklyn Museum, 1990), 24–27 and 31–34.

8. George Crofutt, *Crofutt's New Overland Tourist and Pacific Coast Guide,* 1878–79. Quoted in Patricia Hill, "Picturing Progress in the Era of Westward Expansion," in *The West as America: Reinterpreting Images of the Frontier, 1820–1920,* 134.

9. Brian W. Dippie, "The Moving Finger Writes," in *Discovered Lands, Invented Pasts,* 100–101.

10. Rayna Diane Green, "The Only Good Indian: The Image of the Indian in American Vernacular Culture" (Ph.D. diss., Indiana University, 1973), 46.

11. Peter H. Hassrick, "The Wyoming Cowboy's Evolving Image," in *Wyoming Annals* 65, no. 4 (winter 1993): 13, 14.

12. Robert G. Athearn, *The Mythic West* (Lawrence: University Press of Kansas, 1986): 227.

13. Kenneth Haltman, "Private Impressions and Public Views: Titian Ramsay Peale's Sketchbooks from the Long Expedition, 1819–1820," *Yale University Art Gallery Bulletin,* spring 1989, 46.

14. William H. Goetzmann et al., *Karl Bodmer's America* (Omaha, Neb.: Joslyn Art Museum and University of Nebraska Press, 1984), 3.

15. Robert J. Moore Jr., *Native Americans, A Portrait: The Art and Travels of Charles Bird King, George Catlin, and Karl Bodmer* (New York: Stewart, Tabori, and Chang, 1997), 64.

16. Herman J. Viola, with H. B. Crothers and Maureen Hannan, "The American Indian Genre paintings of Catlin, Stanley, Wimar, Eastman, and Miller," in *American Frontier Life: Early Western Painting and Prints,* ed. Ron Tyler et al. with an introduction by Peter H. Hassrick (New York: Abbeville Press, 1987), 137.

17. "Petition of John M. Stanley" (1852), quoted in Brian W. Dippie, *Catlin and His Contemporaries: The Politics of Patronage* (Lincoln: University of Nebraska Press, 1990), 282–83.

18. Dawn Glanz. *How the West Was Drawn: American Art and the Setting of the Frontier* (Ann Arbor: UMI Research Press, 1982), 40.

19. Linda Ayres, "William Ranney," in *American Frontier Life: Early Western Painting and Prints,* 122. In this essay Ayres discusses the revolver as a symbol of Anglo-American technology that changed the character of encounters with hostile Native Americans and made their tactics archaic.

20. Thomas Virgil Troyon Hill, "Remarks in Father's Letters to Me" (memorandum book) (Oakland, Calif.: Oakland Museum, n.d.). Quoted in Marjorie Dakin Arkelian, *Thomas Hill: The Grand View* (Oakland, Calif.: Oakland Museum Art Department, 1980), 36.

21. *New Path,* May 1863. Quoted in Joshua C. Taylor, *America as Art* (Washington, D.C.: National Collection of Fine Arts, 1976), 121.

22. Frederic Remington, quoted in Alex Nemerov, "Doing the 'Old America': The Image of the American West, 1880–1920," in *The West as America: Reinterpreting Images of the Frontier, 1820–1920,* 287.

23. Hassrick, *Charles M. Russell,* 109.

24. Howard Lamar, "Looking Backward, Looking Forward: Selected Themes in Western Art since 1900," in *Discovered Lands, Invented Pasts,* ed. Jules Prown et al. (New Haven: Yale University Press, 1992), 183.

25. Artists were not allowed to photograph or sketch these sacred ceremonies; thus, they had to rely on memory to recreate these performances.

26. For a complete biography of Brown, see *Grafton Tyler Brown: Nineteenth-Century American Artist* (exhibition brochure), (Washington, D.C.: Evans-Tibbs Collection, 1988).

27. G. T. Brown, artist, "Yellowstone National Park and Pacific Coast Scenery," series 1886, Merrill G. Burlingame Special Collections, col.. 781, box 3, Montana State University Libraries, Bozeman, Mont.

28. Papers of Abby Williams Hill, Collins Memorial Library, University of Puget Sound, Tacoma, Wash. Diary of Abby Williams Hill, "Yellowstone Geyser Basin, Yellowstone Park, Wyo.," August 24, 1906, 215.

29. For a comprehensive study of the life and career of Hill, see Ronald Fields, *Abby Williams Hill and the Lure of the West* (Tacoma: Washington State Historical Society, 1989), 69.

30. Hill Diary, July 30, 1906, 199.

FURTHER READING

Anderson, Nancy K., and Linda S. Ferber. *Albert Bierstadt: Art and Enterprise.* Brooklyn, N.Y.: Brooklyn Museum, 1990.

Armitage, Susan, and Elizabeth Jameson, eds. *The Women's West.* Norman: University of Oklahoma Press, 1987.

Athearn, Robert G. *The Mythic West.* Lawrence: University Press of Kansas, 1986.

Broder, Patricia J. *The American West: The Modern Vision.* Boston: Little, Brown, 1984.

——— . *Bronzes of the American West.* New York: Harry N. Abrams, 1973.

Clark, Carol. *Thomas Moran: Watercolors of the American West.* Austin: University of Texas Press, 1980.

Coen, Rena N. "The Indian as the Noble Savage in Nineteenth-Century American Art." Ph.D. diss., University of Minnesota, 1969.

Coke, Van Deren. *Taos and Santa Fe: The Artist's Environment, 1882–1942.* Albuquerque: University of New Mexico Press, 1963.

Dippie, Brian W. *Catlin and His Contemporaries: The Politics of Patronage.* Lincoln: University of Nebraska Press, 1990.

Ewers, John C. *Artists of the Old West.* Garden City, N.Y.: Doubleday, 1973.

Fenn, Forrest. *The Beat of the Drum and the Whoop of the Dance: A Biography of Joseph Henry Sharp.* Santa Fe: Fenn Publishing Company, 1983.

Fields, Ronald. *Abby Williams Hill and the Lure of the West.* Tacoma: Washington State Historical Society, 1989.

Glanz, Dawn. *How the West Was Drawn: American Art and the Settling of the Frontier.* Ann Arbor: UMI Research Press, 1982.

Goetzmann, William H. *Exploration and Empire.* New York: W. W. Norton, 1978.

Goetzmann, William H. and William N. *The West of the Imagination.* New York: W. W. Norton, 1986.

Green, Rayna Diane. "The Only Good Indian: The Image of the Indian in American Vernacular Culture." Ph.D. diss., Indiana University, 1973.

Grossman, James R. *The Frontier in American Culture.* Berkeley: University of California Press, 1995.

Hassrick, Peter H. *Charles M. Russell.* New York: Harry N. Abrams, 1989.

——— . *The Way West.* New York: Harry N. Abrams, 1977.

Hendricks, Gordon. *Albert Bierstadt: Painter of the American West.* New York: Harry N. Abrams, 1974.

Hoopes, Donaldson F. *The Dusseldorf Academy and the Americans.* Atlanta: High Museum of Art, 1972.

Moore, Robert J., Jr. *Native Americans, A Portrait: The Art and Travels of Charles Bird King, George Catlin, and Karl Bodmer.* New York: Stewart, Tabori, and Chang, 1997.

Novak, Barbara. *American Painting of the Nineteenth Century.* New York: Praeger Publishers, 1969.

——— . *Nature and Culture: American Landscape Painting, 1825–1875.* New York: Oxford University Press, 1980.

Prown, Jules D., et al., eds. *Discovered Lands, Invented Pasts: Transforming Visions of the American West.* New Haven: Yale University Press, 1992.

Ross, Marvin C., ed. *The West of Alfred Jacob Miller.* Norman: University of Oklahoma Press, 1951.

Sweeney, J. Gray. *Masterpieces of American Western Art.* New York: Mallard Press, 1991.

Taft, Robert. *Artists and Illustrators of the Old West.* New York: Charles Scribner's Sons, 1953.

Taylor, Joshua C. *America as Art.* Washington, D.C.: National Collection of Fine Arts, 1976.

Trenton, Patricia. *Picturesque Images of Taos and Santa Fe.* Denver: Denver Art Museum, 1974.

Trenton, Patricia, and Peter H. Hassrick. *The Rocky Mountains: A Vision for Artists in the Nineteenth Century.* Norman: University of Oklahoma Press, 1983.

Truettner, William H. *The Natural Man Observed: A Study of Catlin's Indian Gallery.* Washington, D.C.: Smithsonian Institution Press, 1979.

Truettner, William H., ed. *The West as America: Reinterpreting Images of the Frontier, 1820–1920.* Washington, D.C.: National Museum of American Art, Smithsonian Institution Press, 1991.

Tyler, Ron, ed. *Alfred Jacob Miller: Artist of the Oregon Trail.* Fort Worth, Tex.: Amon Carter Museum, 1982.

Tyler, Ron, et al., eds. *American Frontier Life: Early Painting and Prints.* Introduction by Peter H. Hassrick. New York: Abbeville Press, 1987.

Wilkins, Thurman. *Thomas Moran: Artist of the Mountains.* Norman: University of Oklahoma Press, 1998.

INDEX OF ARTISTS

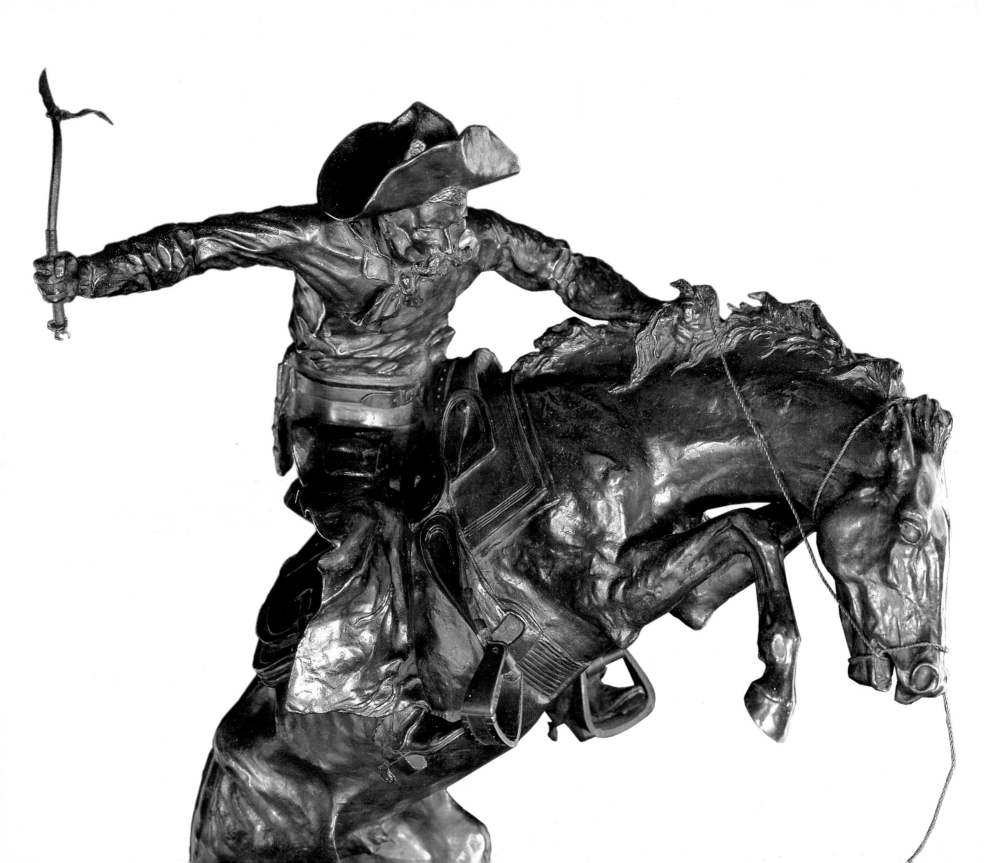